Unknown Impressionists

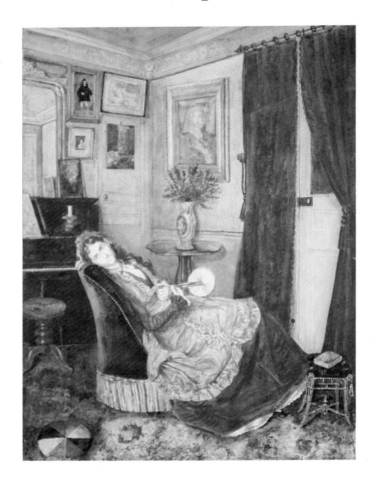

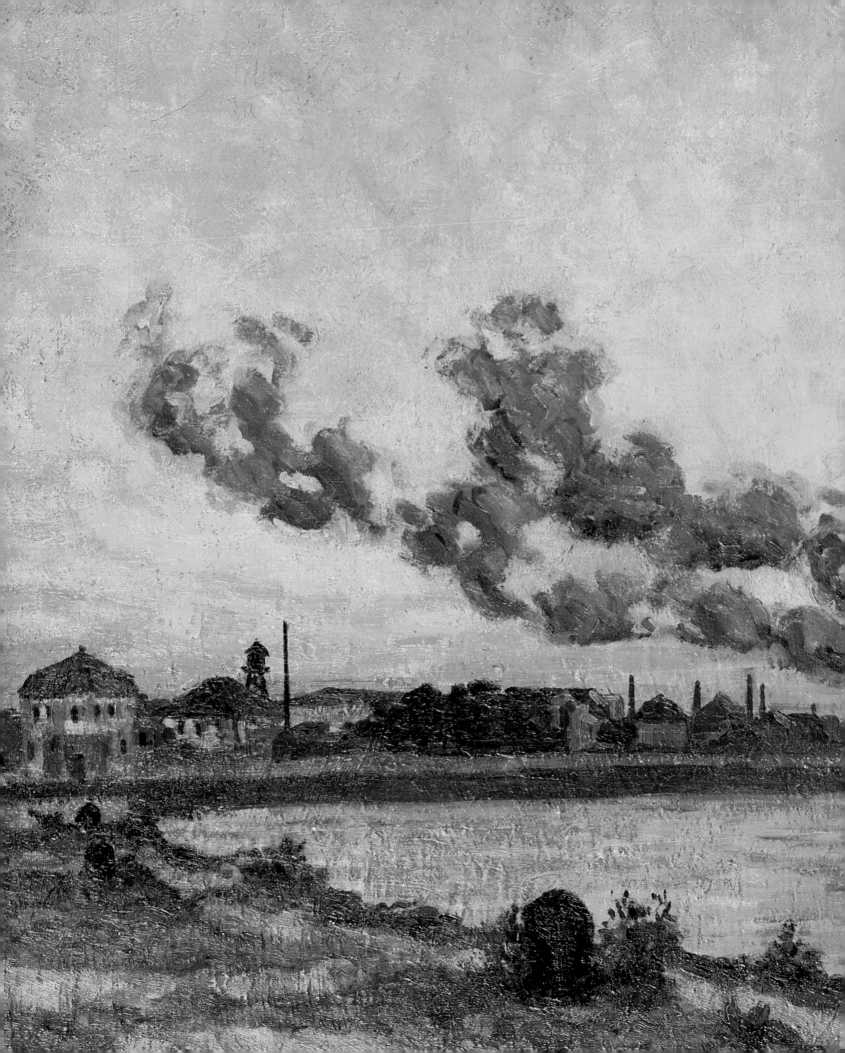

KATHLEEN ADLER

Unknown Impressionists

PHAIDON · OXFORD

Phaidon Press Limited, Littlegate House, St Ebbe's Street, Oxford, OX1 1SQ

First published 1988

© Phaidon Press Limited 1988

British Library Cataloguing in Publication Data

Adler, Kathleen
 Unknown Impressionists.
 1. Painting, French 2. Impressionism
 (Art)—France
 I. Title
 759.4 ND547.5.14

 ISBN 0–7148–2452–6

Phototypeset by Wyvern Typesetting Ltd, Bristol

Printed in West Germany by Mohndruck Graphische Betriebe GmbH. Gütersloh

(*Half-title*) Zacharie Astruc. *Parisian Woman in an Interior. c.*1874. Watercolour. Evreux, Musée d'Evreux

(*Frontispiece*) Jean-Baptiste-Armand Guillaumin. *Sunset at Ivry.* 1873. Oil on canvas, 65 × 81 cm. Paris, Musée d'Orsay

Contents

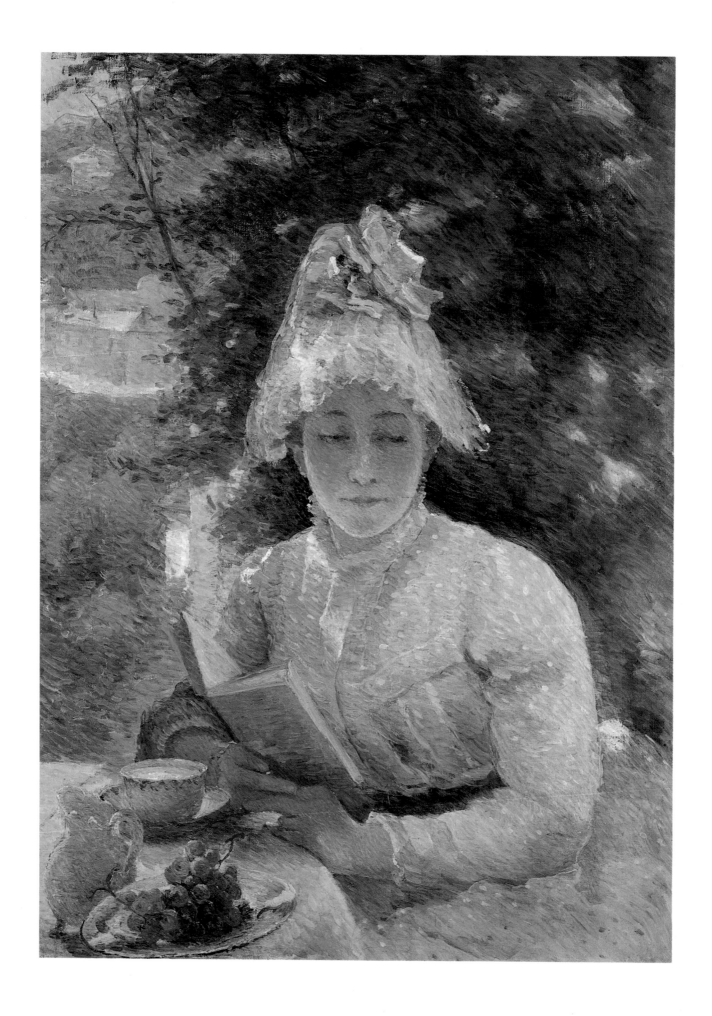

to Sue

My thanks to Tamar Garb, for listening to me and talking about this project; to
John House, for his helpful and constructive comments and criticism; to Penelope
Marcus, for her patience; and to Denise Hardy, for the picture research.

1. Marie Bracquemond. *Tea Time*. 1880. Oil on canvas, 81.5 × 61.5 cm. Paris, Musée du Petit Palais

Preface

The 'unknown Impressionists' in this book all participated in at least one of the eight group shows held between 1874 and 1886. We now call these the 'Impressionist' exhibitions, but the artists themselves preferred to call them 'independent' exhibitions. They wished to be independent from the annual Salons, the huge public displays of art held in the Palais de l'Industrie in the Champs Elysées, and from the burgeoning dealer system; free from the constraints imposed either by jury selection or by the preferences of an individual dealer. They were also fiercely proud of their individuality, and had no wish to be subsumed under a group identity.

Although many accounts present Impressionism as a unified movement, with a common artistic aim and purpose, the work on view at the exhibitions was extremely diverse and the artists represented a variety of points of view. The illustrations in this volume reveal the range and heterogeneity of their art. Of the various categories of Salon art, only that of history painting was absent from the group shows, with the emphasis being on modern life painting and on landscape. The paintings exhibited in the eight shows were seldom on the scale of the great Salon *machines*: Caillebotte's *Paris Street, A Rainy Day*, shown at the third exhibition, and Seurat's *Sunday Afternoon on the Île de la Grande-Jatte*, at the eighth show, were exceptional. The viewing conditions at the exhibitions made it possible to look at easel-sized paintings without their being swamped by larger works, as was the case at the Salon. By nineteenth-century standards, if not our own, the hanging was exceptionally spacious: there were usually two rows of paintings, the larger works hung above the smaller ones, instead of the floor to ceiling hang of the Salons. Drawings and other graphic work constituted an important element of the work on view, and artists were able to show a larger and more varied selection of work than was possible at the Salons.

This book attempts to widen the scope of what is generally meant by Impressionism. Impressionism today is so familiar and so easily accepted that its definition may appear unproblematic, but as chapter one suggests, this is not the case. Many factors need to be considered when defining Impressionism, not only regarding technique, but also concerning participation in the group exhibitions, and the aims and intentions of these exhibitions. Even when limiting the choice of artists, as I have done here, to artists directly involved in the group shows, rather than extending the scope of the book to the many thousands of painters, in the nineteenth and in the twentieth century, throughout Europe and the United States, who embraced a form of Impressionism as a style of painting, the definition of Impressionism is not self-evident. Chapter two considers the exhibitions and the roles played in their formulation and organization by painters whose names may be almost entirely unknown today. The unknown figures contributed in both positive and negative senses to the shows: positively by working for them, sometimes financing them, extending the range of work on view; negatively by provoking some of the splits and bad feeling that marked the

organization of all but the first two exhibitions. Chapter three deals with the group of painters who gathered around Camille Pissarro at Pontoise. It considers the importance they attached to the concept of '*sensation*', and how they saw this concept as enabling them to realize an individual vision of the landscape. The fourth chapter looks at several individuals who were crucial for the survival of the independent shows—those painters who were also patrons and who were welcomed into the group in their capacity as collectors. The fifth chapter examines the painters, centred on the figure of Edgar Degas, who may be defined as 'realists'.

Many of the individuals discussed in this book were interesting and able artists, but it is not my intention to try to promote them to the canon of 'great artists' or to suggest that they have been unfairly treated in not being ranked alongside Monet, Renoir, Degas, or Cézanne. It is my aim to show that the subsequent canonization of these latter artists, and the often repeated story of Impressionism as an epic struggle between, on the one hand, a monolithic establishment art world and, on the other, a courageous band of kindred spirits is oversimplified and distorted. By examining the work and the contribution of the 'unknown Impressionists' we may be able to see Impressionism as more complicated, less clearly defined and organically united than it sometimes seems, and also as a changing, fragmented but vibrant and exciting moment in the history of nineteenth-century painting.

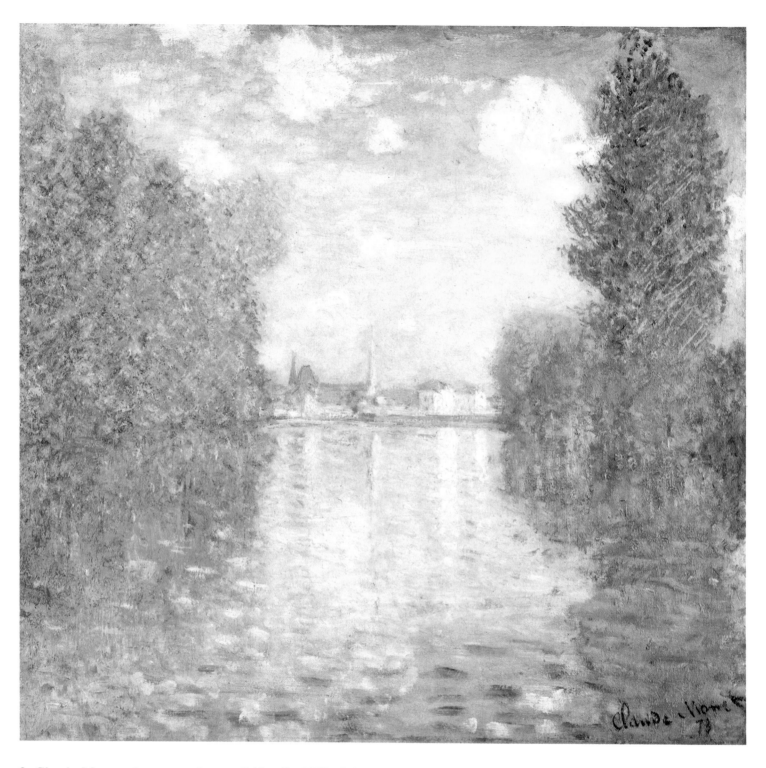

2. Claude Monet. *Autumn at Argenteuil* (detail). 1873. Oil on canvas, 56 × 75 cm. London, Courtauld Institute Galleries, Courtauld Collection

1 What is Impressionism?

When the eighth and last Impressionist exhibition closed on 15 June 1886, it brought to an end twelve years of independent group shows, in which fifty-eight artists had participated. They included painters who are now among the best-known names in art history: Monet, Renoir, Degas, Cézanne, Pissarro. At the independent exhibitions, their work always hung together with paintings by far less familiar figures, some of whom were largely unregarded even in their own day, others who have suffered from the vagaries of critical and art historical writing in our own century.

The number of participants and the range of approaches displayed at individual exhibitions over the period from 1874 to 1886 during which the exhibitions were held raises the question: 'What is Impressionism?' At first the answer might appear to be simple and obvious: a painting of an open-air scene, probably by Monet (Pl. 2), revealing an interest in changing effects of light and colour, painted with a considerable degree of freedom and apparent spontaneity, emphasizing the materiality of the painted surface. To be content with this definition would be to ignore the heterogeneity of the works on view at the eight exhibitions. It would also ignore the context of the Parisian art world during the first decade and a half of the Third Republic: the independent shows must be located within this context, for they responded directly to its shifts and fluxes. They did not exist in the vacuum in which much art historical writing has set them.

By the 1880s paintings of modern life subjects, often employing a palette and freedom of handling which owed much to the example of the artists who chose the independent exhibitions as their forum, were praised when they were shown within a different context. Henry Houssaye pointed this out in 1882: 'Impressionism receives every form of sarcasm when it takes the names Manet, Monet, Renoir, Caillebotte, Degas—every honour when it is called Bastien-Lepage, Duez, Gervex, Bompard, Danton, Goeneutte (Pl. 3), Butin, Mangeant, Jean Béraud, or Dagnan-Bouveret.' A variant of Impressionism became a popular mode of painting in Europe, particularly in Germany and Scandinavia, and in the United States, in the last twenty years of the nineteenth century, somewhat later in Britain, and continued to be employed until well into this century. The work of some of the original participants in the exhibitions continued to remain controversial. In 1907 Roger Fry's recommendation that the Metropolitan Museum of Art in New York purchase Renoir's *Madame Charpentier and her Children* provoked such outrage among the trustees that he was almost forced to resign, and as late as 1964 the acquisition of Cézanne's *Les Grandes Baigneuses* by the National Gallery in London led to howls of public indignation. However, a diluted form of Impressionism became the stock in trade of many thousands of painters, amateur and professional alike.

When the first exhibition of the group calling themselves the *Société anonyme des artistes peintres, sculpteurs, graveurs, etc.,* opened in the premises previously occupied by the photographer Nadar at 35 Boulevard des Capucines

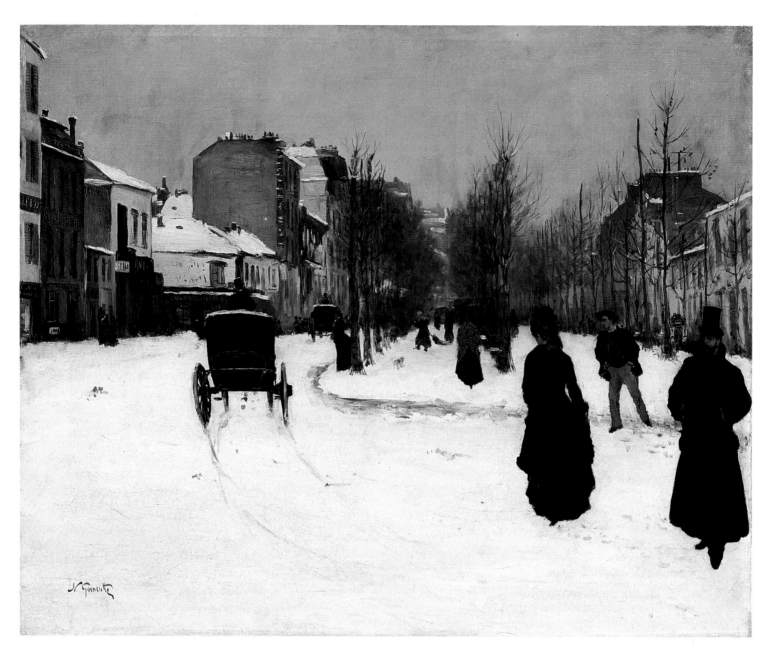

3. Norbert Goeneutte. *Boulevard de Clichy under Snow*. 1876. Oil on canvas, 60 × 73.5 cm. London, Tate Gallery

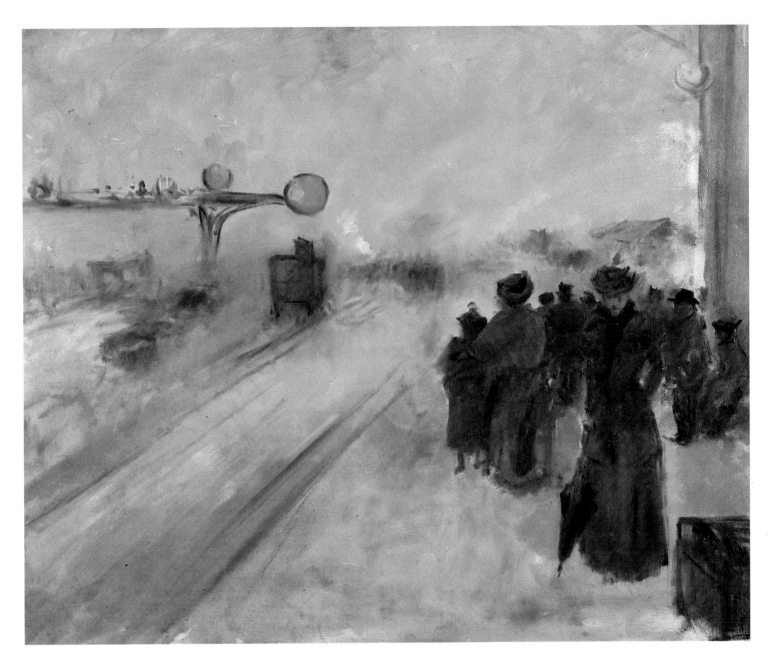

4. Jean-Louis Forain. *A Study of Fog in a Station. c.*1884. Oil on canvas, 45.1 × 55.8 cm. New York, Collection of Adele and Irving Moskovitz

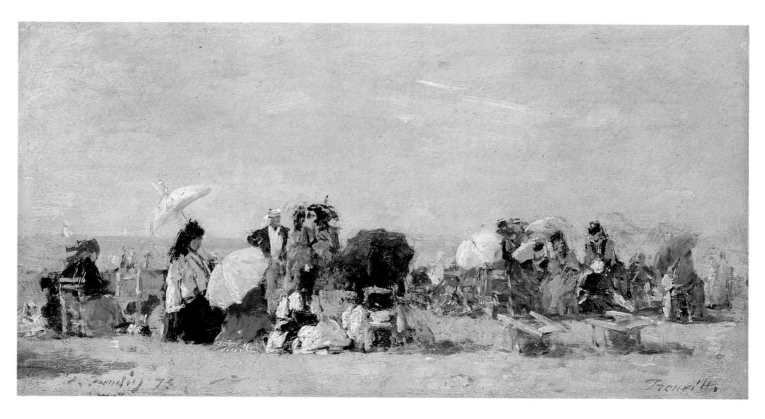

5. Eugène Boudin. *The Beach at Trouville*. 1873. Oil on panel, 15.2 × 29 cm. London, National Gallery

6. Giuseppe de Nittis. *On the Banks of the Seine*. 1870s. Oil on canvas, 27 × 35 cm. Private collection

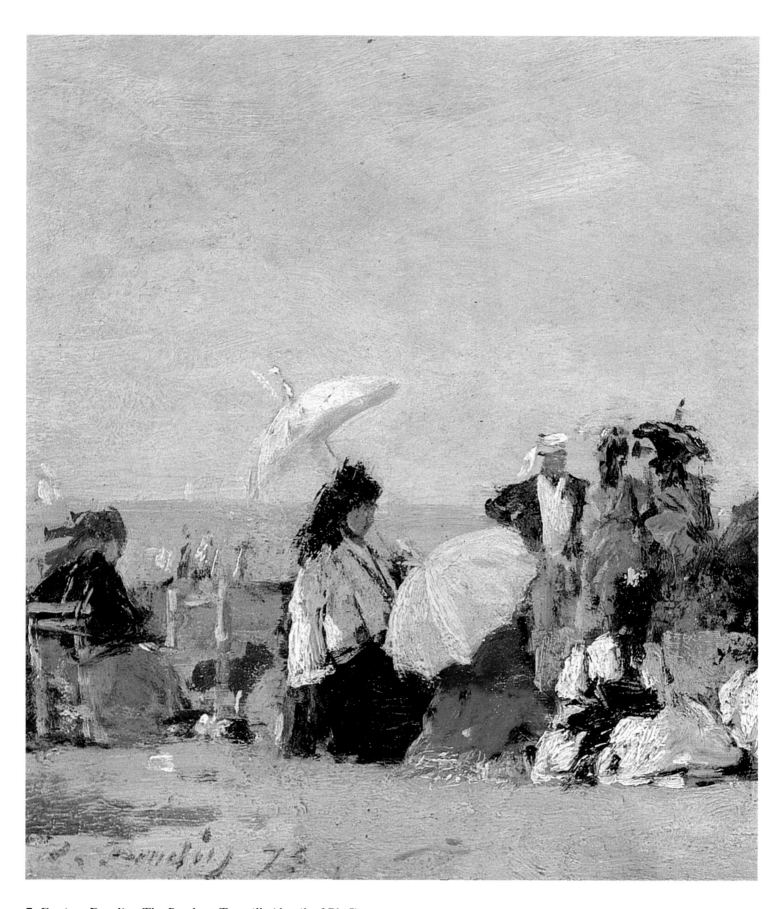

7. Eugène Boudin. *The Beach at Trouville* (detail of Pl. 5)

8. Giuseppe de Nittis. *On the Banks of the Seine* (detail of Pl. 6)

in Paris on 15 April 1874, the thirty participants represented a wide range of interests. They were all members of a co-operative society who had paid sixty francs annual subscription and whose charter gave each member the right to hang two works. Hanging positions were determined by ballot, and a governing body of fifteen members, one-third of whom were to be replaced each year, took care of the many administrative decisions and duties. The aims of the co-operative were to organize exhibitions without jury selection or honorary awards; to sell the works; and to publish a journal exclusively related to the arts. Among the founding members were Armand Guillaumin and Edouard Béliard, both friends of Pissarro's; Jean-Baptiste Léopold Levert; Stanislas-Henri Rouart, a friend of Degas since their schooldays; the sculptor Auguste Ottin; Vicomte Ludovic-Napoléon Lepic; and Alfred Meyer, all relatively unknown today, but all committed to the idea of an alternative form of exhibition to the Salon. Other artists, some of whom exhibited regularly at the Salons, like Eugène Boudin (Pls. 5, 7), Louis Debras and Antoine-Fernand Attendu, were recruited before plans for the first exhibition were finalized.

Some of the founding group had been discussing the possibility of organizing a group show independent of the Salon since 1867. It was then that Frédéric Bazille, who was to be killed during the Franco-Prussian War, wrote to his parents: 'I told you about the plan of a group of young people to have their separate exhibition. With each of us pledging as much as possible, we have been able to gather the sum of 2,500 francs, which is not enough. We must therefore abandon our desired project. We will have to re-enter the bosom of the administration whose milk we have not sucked and who disowns us.' He wrote that they had decided 'that each year we will rent a large studio where we will exhibit our works in as large a number as we please.' He claimed that Gustave Courbet, Camille Corot, Virgile Narcisse Diaz de la Peña and Charles Daubigny had promised to participate in the exhibitions, and that their support would ensure the exhibitions' success. But seven years later, when the first exhibition finally opened, none of these artists was represented. Corot was openly hostile to the venture: he wrote to Antoine Guillemet commending his decision to continue showing at the Salon, remarking, 'My dear Antoine, you have done very well to escape from that gang.'

The years immediately after the Franco-Prussian War were boom years for the Paris art market. Elizabeth Jane Gardner, an American artist living in Paris who later married the fashionable Salon painter Bouguereau, wrote to an American collector early in 1872:

This has not been a favourable season for advantageous purchases—the artists worked but little for a year. A lot of purchasers flocked to Paris after the war thinking to find good bargains. The merchants have felt determined to keep up the prices. Many owners of valuable collections have profited by this state of affairs to make money on their galleries. There has been a series of auctions of beautiful paintings ancient and modern, which have brought fabulous prices. There has been a mania for buying at auction and small paintings have brought from 5,000 to 100,000 francs

Among the dealers to benefit from this upsurge was Paul Durand-Ruel, who had returned to Paris after spending the war years in London. While some of the future participants in the Impressionist exhibitions, such as Henri Rouart, bought pictures from Durand-Ruel, others, primarily Monet, Pissarro and Sisley, sold much of their work to him in these years. Durand-Ruel made major purchases of Manet's paintings at this time, but the bulk of his stock consisted of work of the Barbizon school, which was starting to fetch high prices. The combination of a sympathetic dealer and the high prices fetched at auctions in 1872 and 1873 encouraged artists like Pissarro, but this optimism was short

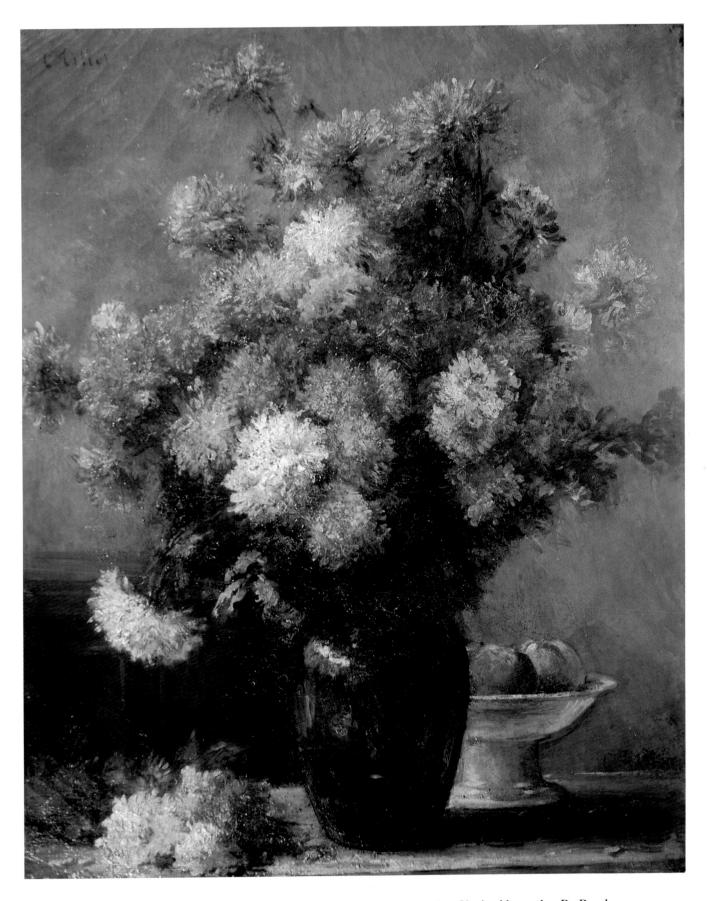

9. Charles Tillot. *Flowers — Still Life.* Oil on canvas, 81.5 × 65 cm. New York, Alexander R. Raydon, Raydon Gallery

10. Adolphe-Félix Cals. *The Cotton Waste Breakers*. 1877. Oil on canvas,
51 × 62 cm. Paris, Musée d'Orsay

11. Adolphe-Félix Cals. *The Meal at Honfleur*. 1875. Oil on canvas,
45.5 × 54 cm. Paris, Musée d'Orsay

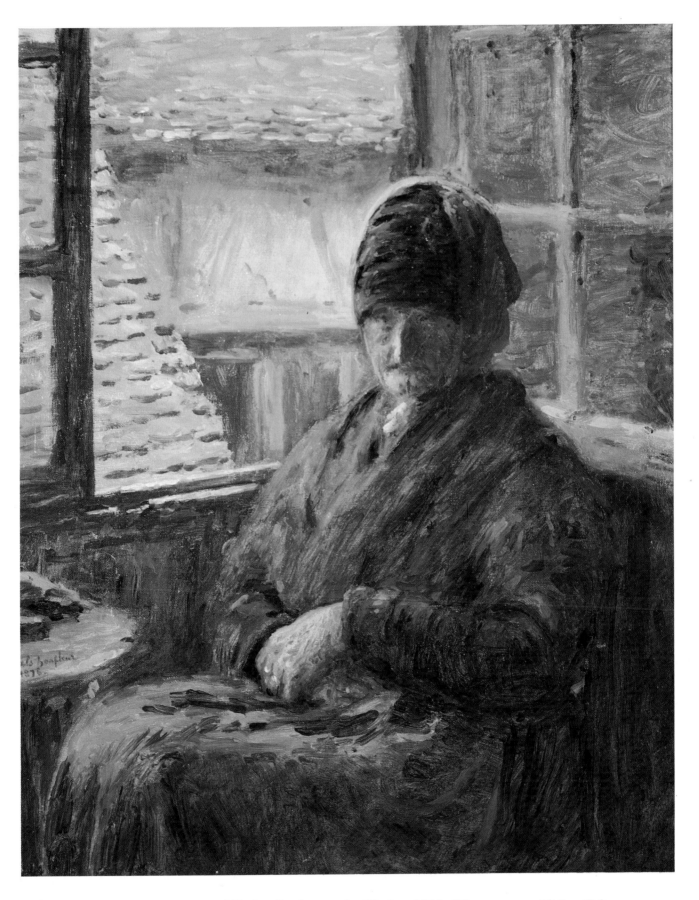

12. Adolphe-Félix Cals. *Portrait of Mother Boudoux at the Window*. 1876. Oil on canvas, 60.6 × 48.3 cm.
Memphis, Dixon Gallery and Gardens

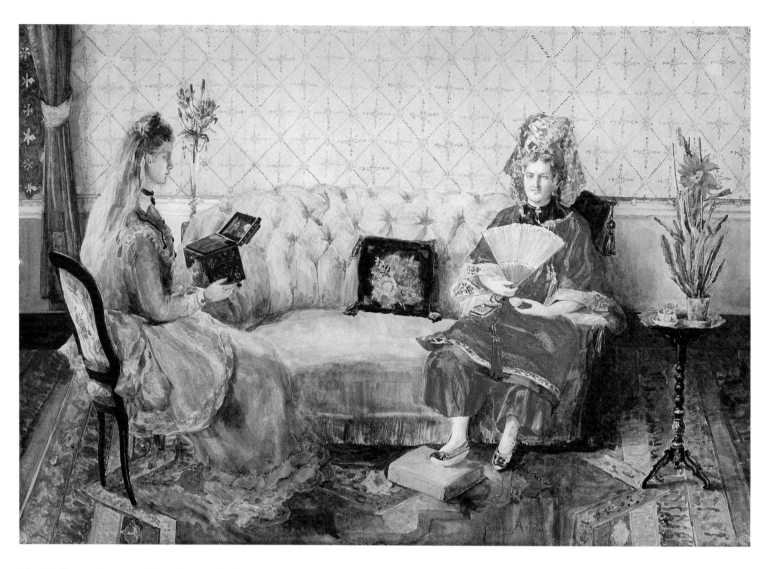

13. Zacharie Astruc. *The Chinese Gifts, London. c.*1873. Watercolour on paper, 38 × 55 cm. New York, Collection of Dr Sharon Flescher

14. Henry Somm. *The Red Overcoat.* Watercolour. Rouen, Musée des Beaux-Arts

15. Félix Bracquemond. *At the Jardin d'Acclimatation*. 1873. Colour etching and aquatint, 18.7 × 20 cm. Boston, Museum of Fine Arts.

lived. By the beginning of 1874 Durand-Ruel found himself overstocked with paintings by Monet, Sisley and Pissarro, which he was finding increasingly difficult to sell. Soon after the first exhibition opened, he virtually stopped buying the work of the Impressionists for six years.

Many of the participants in the first exhibition were not in the relatively fortunate position in which Pissarro found himself at the beginning of 1874. Artists were dependent on the Salon for public and critical recognition, and often they fared badly at the hands of the jury and were not accepted. The Salon was held annually in the Palais de l'Industrie on the Champs Elysées, and at least until the early 1880s, it was the most important venue for the display of contemporary painting in Paris. Here, thousands of paintings and sculptures were displayed in thirty rooms, hung from floor to ceiling, occasionally with frames overlapping. Even when the hurdle of passing the jury's scrutiny had been overcome, the quantity of paintings and the method of hanging adopted did not guarantee that the work would attract attention. Despite the length and quantity of reviews generated by each Salon, many painters and paintings went unnoticed. The dominance of the Salon condemned hundreds of painters to battle endlessly against its suffocating structure, believing, as the critic Théodore Duret said in a letter to Pissarro, that 'you must succeed in making a noise, in defying and attracting criticism, in coming face to face with the great public. You can't achieve all that except at the Palais de l'Industrie.'

The Salon exhibitions were seen by tens of thousands of people, in marked contrast to the far smaller audience for the independent shows, and it was within its constraints that some painters, Manet for instance, felt that the battle for progressive painting had to be fought. The artists who participated in the eight independent shows had many different attitudes to the Salon: some rejected it entirely once they had committed themselves to the idea of group exhibitions; others returned to it briefly; some, such as Giuseppe de Nittis, showed only once in the independent forum before choosing to submit to the Salon; still others, like Forain, showed with the independents as a way of establishing themselves before turning to other avenues.

The process of jury selection meant that each year hundreds of works were rejected, and in 1873, as had occurred a decade earlier, the administration gave way to the artists' protests, and decreed that a Salon des Refusés be held. Among those who showed at this *Exposition des oeuvres refusés* were Renoir, whose *Morning Ride in the Bois de Boulogne* (Hamburg, Kunsthalle) was praised by critics, and Henri Rouart, who purchased Renoir's canvas. But several of the founding members of the independent group had decided not to submit anything to the Salon in 1873, and the severity of the jury's selections made the necessity for an alternative forum all the more pressing.

It was clear, however, that if all the artists showing with the independent group were known as *refusés*, any exhibition would be branded by critics as the work of failures. For this reason, Degas in particular was eager to recruit painters who had shown at the Salon, among them de Nittis (Pls. 6, 8). De Nittis, born in Naples in 1846, had come to Paris in 1867. He soon was showing regularly at the Salon. He secured a contract with Adolphe Goupil, the most prominent art merchant in Paris, and obtained regular invitations to the salons of the Princesse Mathilde, Napoléon III's cousin. Degas told de Nittis: 'Since you are exhibiting at the Salon, people who are not conversant with things won't be able to say that ours is an exhibition of rejected artists.' For de Nittis, the decision to accept Degas's invitation and show five works with the group must have been taken only in order to extend the range of his potential buyers. Following the 1874 exhibition, he pursued his successful career as a Salon painter, often noticed and usually praised by the critics.

Among the older artists who were recruited for the first show were Monet's first teacher, Eugène Boudin (Pls. 5, 7), and another marine painter, Adolphe Cals. Boudin was fifty, and as the critic Jules Castagnary pointed

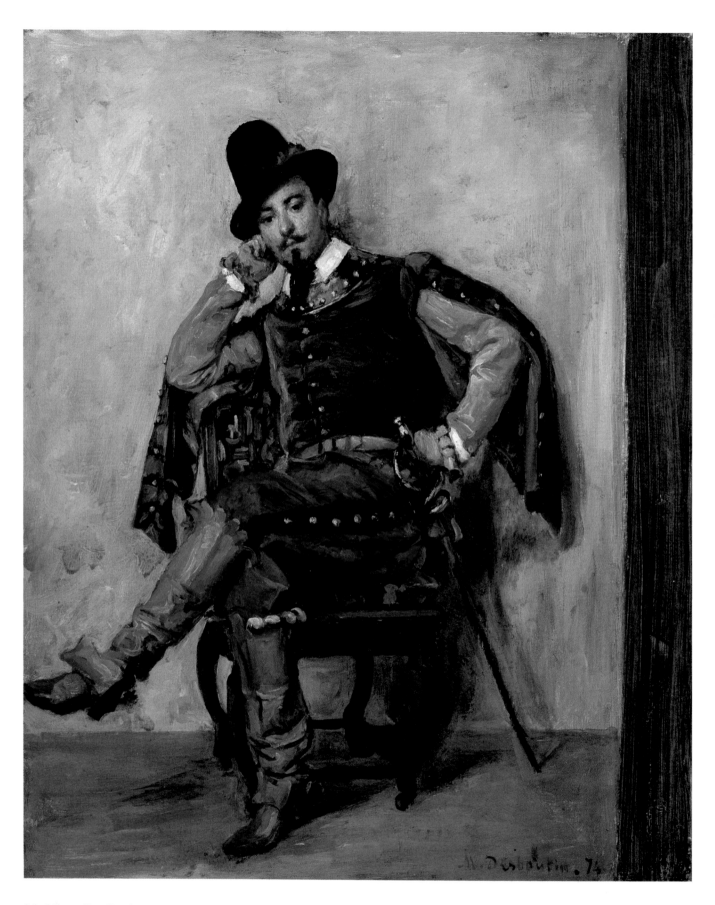

16. Marcellin Desboutin. *Portrait of Jean-Baptiste Faure*. 1874. Oil on canvas, 40.8 × 32.7 cm. New York, Wheelock Whitney and Company

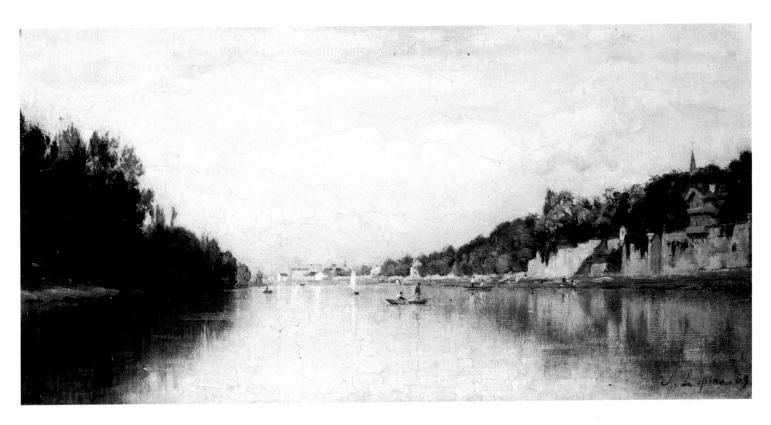

17. Stanislas Lépine. *Banks of the Seine*. 1869. Oil on canvas, 30 × 58.5 cm. Paris, Musée d'Orsay

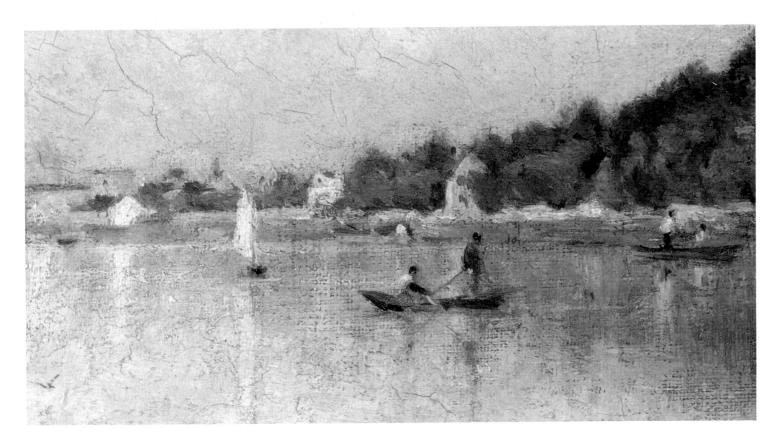

18. Stanislas Lépine. *Banks of the Seine* (detail of Pl. 17)

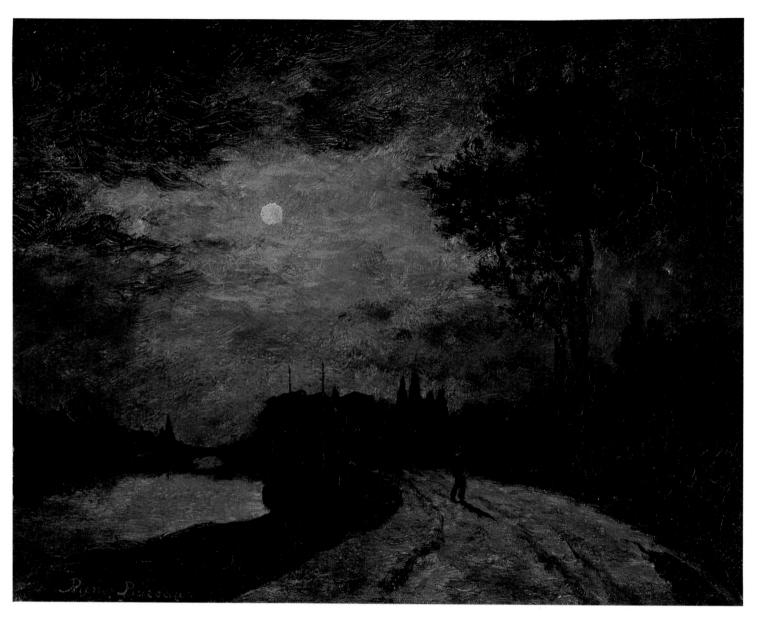

19. Pierre-Isidore Bureau. *Moonlight at L'Isle-Adam*. 1867. Oil on canvas, 33 × 41 cm. Paris, Musée d'Orsay

20. Alphonse Legros. *The Death of a Vagabond*. 1876. Etching, aquatint and dry point, 53.7 × 37.7 cm. Dublin, Hugh Lane Municipal Gallery of Modern Art

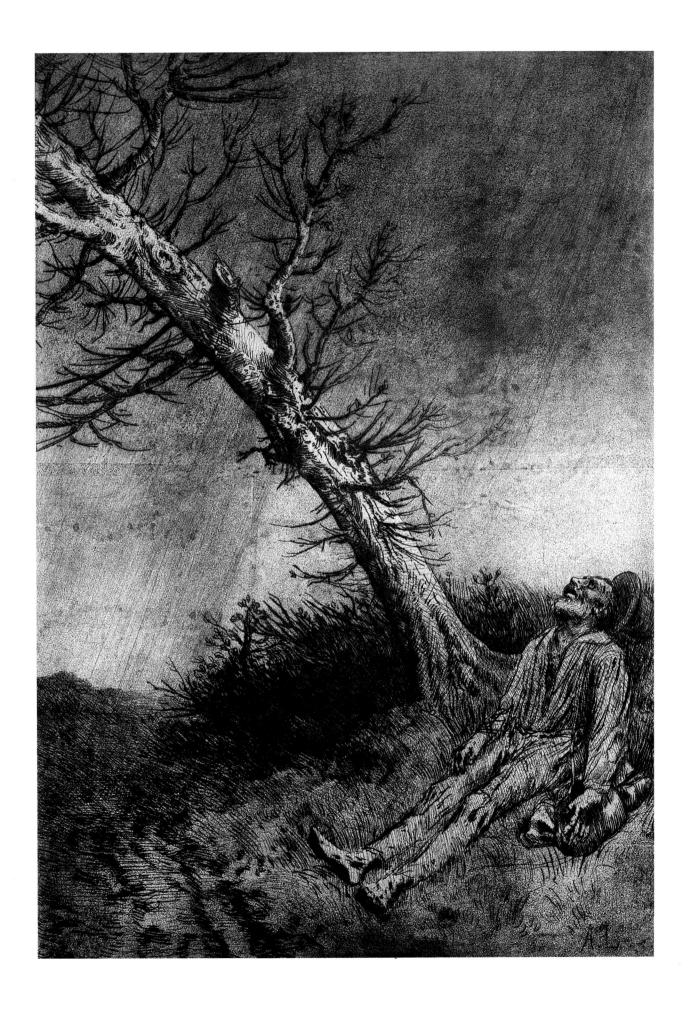

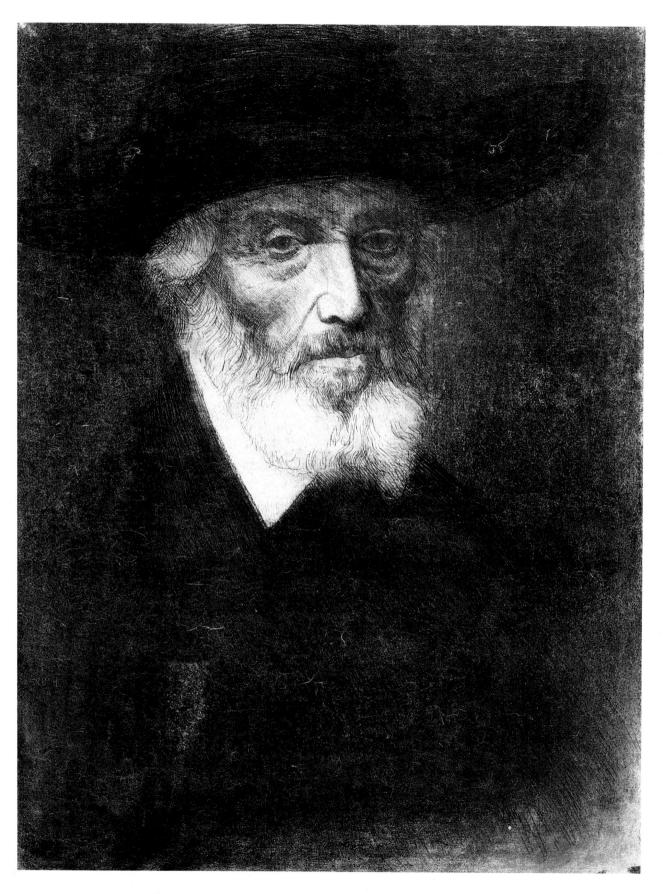

21. Alphonse Legros. *Portrait of Carlyle*. 1876. Etching. Paris, Bibliothèque Nationale, Cabinet des Estampes

out, he had commanded respect for years, and was securing high prices for his seascapes. Cals was sixty-four, and had been exhibiting at the Salon since 1831. He painted regularly at the farm at Saint-Siméon in the hills above Honfleur, in Normandy (Pl. 11), which looked out over the Seine estuary below. Many artists had gathered there to paint *en plein air* in the 1860s, including Boudin, Monet, Corot, Daubigny and Courbet, and the farm was often referred to as the 'Barbizon of Normandy'. In 1873 Cals decided to buy a property in Honfleur, and he spent the remaining seven years of his life there. His move to Honfleur coincided with his decision to stop sending work to the Salon, and he chose to exhibit with the newly formed independent group as a matter of principle; a letter he wrote to his friend Troubet in 1879 makes this clear: 'What, above all, prompted me to join [the Independents] was my belief that only one thing can save our art, and this is the rigorous application of the principle of liberty.' In later exhibitions Cals's submissions included *Portrait of Mother Boudoux at the Window* (Pl. 12) and *The Cotton Waste Breakers* (Pl. 10). After the first show, he participated in all the subsequent exhibitions until his death in 1879, and his work was shown in the 1881 exhibition in posthumous tribute.

The range of interests and approaches represented at the first show covered a wide spectrum. It included many small works, such as the watercolours of Zacharie Astruc, critic, poet and close friend of Manet (*Half-title*, Pl. 13); etchings by Edouard Brandon (Pl. 34); small canvases by Pierre-Isidore Bureau (Pl. 19). The number of watercolours, drawings and graphic works, as well as small oil paintings, is a reminder that the one of the exhibitions' main purposes was to attract buyers. The exhibits in 1874 ranged from the gentle tonal landscapes and cityscapes of Stanislas Lépine (Pls. 17, 18, 32, 33) to the works that provoked controversy, such as Monet's and Cézanne's. They were haphazardly hung, often according to size, but each artist's work was kept together, and large works were hung above small ones. There was no over-riding unifying factor.

Subsequent exhibitions repeated this pattern: the paintings of Marie Bracquemond (Pls. 1, 27, 28), which in subject matter and technique can easily be accommodated within conventional definitions of 'Impressionism', hung with her husband Félix's intensely illusionistic and wholly un-Impressionist *Portrait of M. Edmond de Goncourt* (Pl. 23) at the fifth exhibition in 1880. Better known as an etcher, Félix Bracquemond showed graphic work at the fourth exhibition (Pls. 15, 24, 35), while Marcellin Desboutin, a specialist in dry points (Pl. 25). chose to exhibit paintings such as *Portrait of Jean-Baptiste Faure* (Pl. 16) in 1876. Charles-Albert Lebourg exhibited with the independents in 1879 and 1880, showing a combination of landscapes, many of them views of Algiers (Pl. 30), and drawings, among them possibly the atmospheric *The Artist's Wife and Mother-in-Law Reading a Letter by Candlelight* (Pl. 22). Alphonse Legros, a London resident since the Franco-Prussian War, exhibited mainly graphic works (Pls. 20, 21) once only, in 1876; Alphonse Maureau showed small panels (Pl. 31) at the third exhibition in 1877; Henry Somm displayed prints and book illustrations in 1879 (Pls. 14, 29).

From the first, some critics regarded this diversity as a problem. Ernest Chesneau, writing in *Paris-Journal*, commented: 'To have invited to exhibit together both those painters who lag at the very tail end of the latest banalities of the official Salons and those who show real talent, but who work in a very different direction—such as de Nittis, Boudin, Bracquemond, Brandon, Lépine and Gustave Colin—this was a major error in logic and strategy.'

The question remains: do we describe all those who participated at this first show as 'Impressionists'? The exhibitors themselves deliberately chose the most neutral possible title for their show, simply the first exhibition of the *Société anonyme des artistes peintres, sculpteurs, graveurs, etc.* When Degas had proposed calling the group *La Capucine* [The Nasturtium], because the premises at which they showed were on the Boulevard des Capucines, the others objected. Even before the exhibition closed, many of the critics and visitors had dubbed it an exhibition of

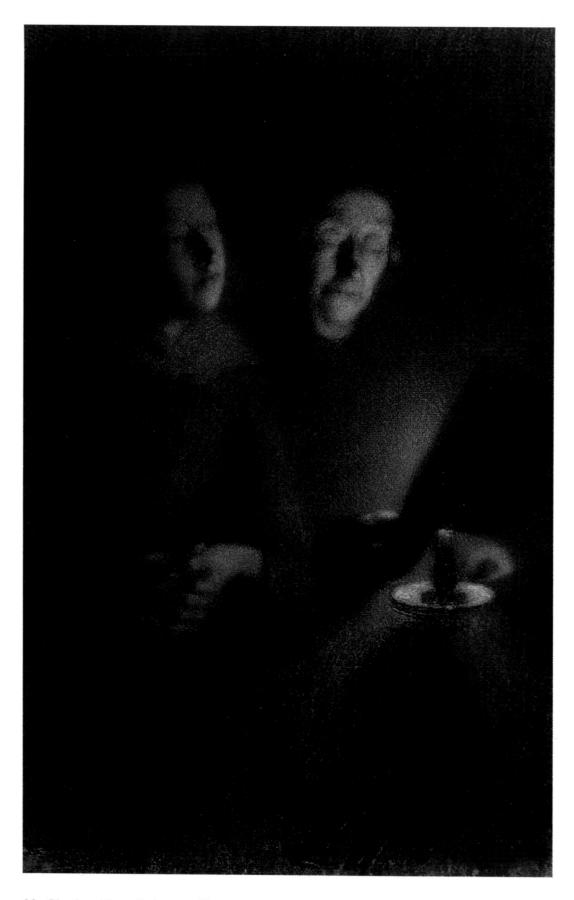

22. Charles-Albert Lebourg. *The Artist's Wife and Mother-in-Law Reading a Letter by Candlelight. c.*1879. Chalk on paper, 43.5 × 28.3 cm. London, British Museum.

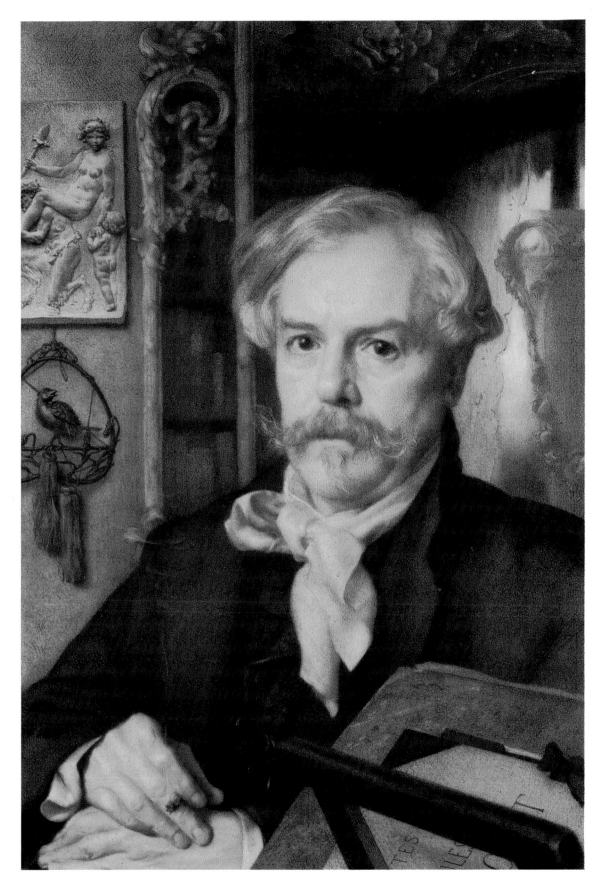

23. Félix Bracquemond. *Portrait of M. Edmond de Goncourt*. 1880. Charcoal on canvas,
55 × 37.9 cm. Paris, Musée du Louvre, Cabinet des Dessins

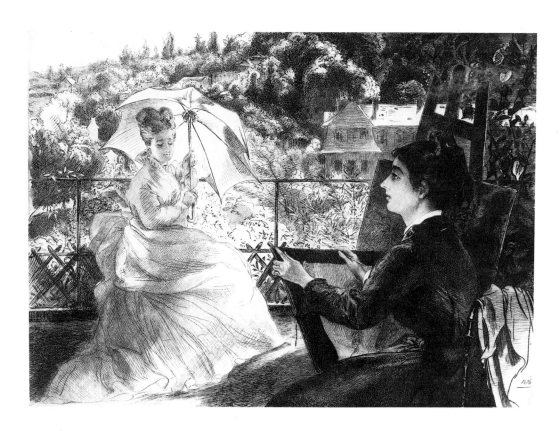

24. Félix Bracquemond. *The Terrace of the Villa Brancas*. 1876. Etching, 25.5 × 35.5 cm. London, British Museum

25. Marcellin Desboutin. *Portrait of Berthe Morisot*. c.1876. Dry point, 26.7 × 17.7 cm. London, William Weston Gallery

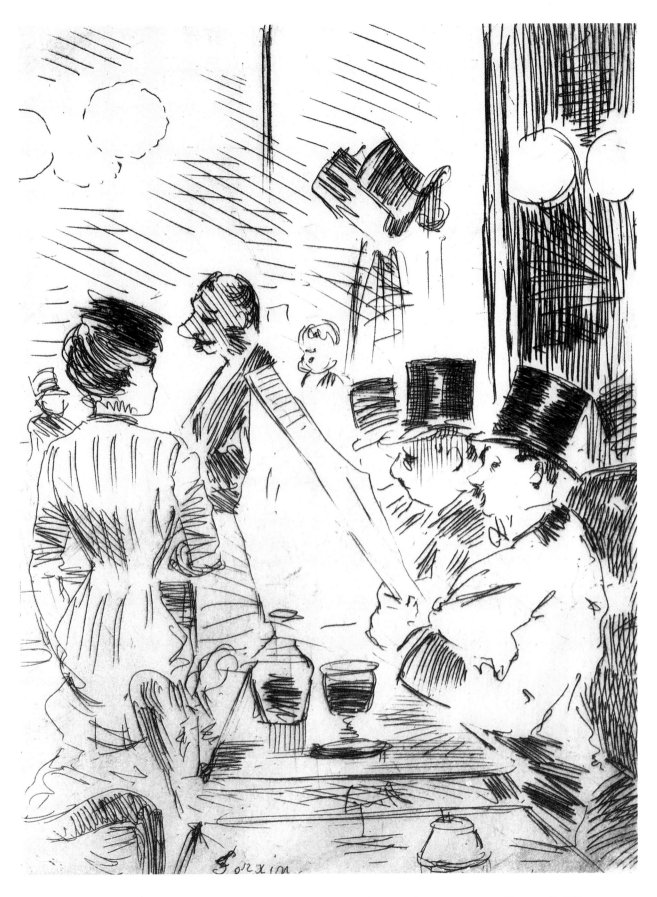

26. Jean-Louis Forain. *The Café de la Nouvelle-Athènes. c.*1876. Etching on paper. Boston Public Library, Wiggin Collection

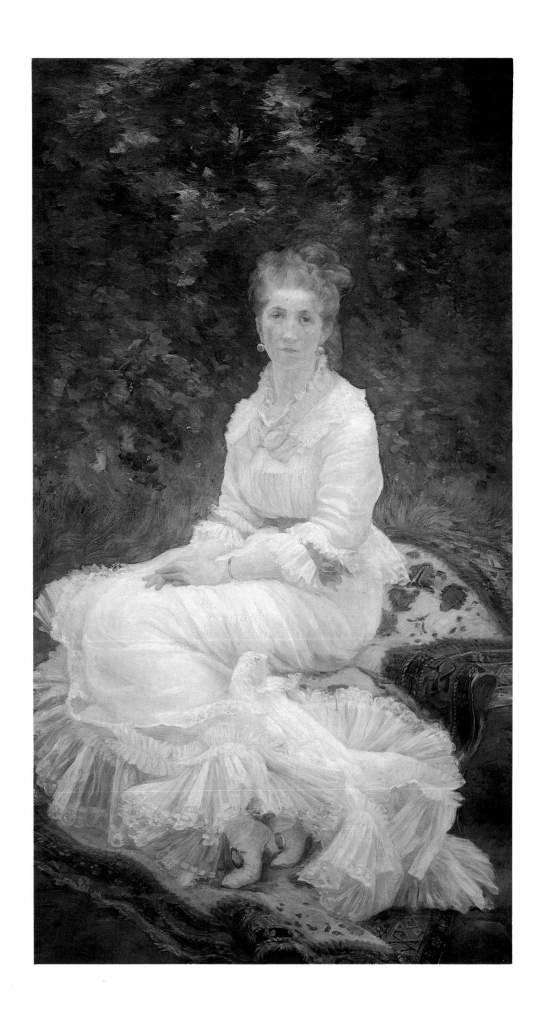

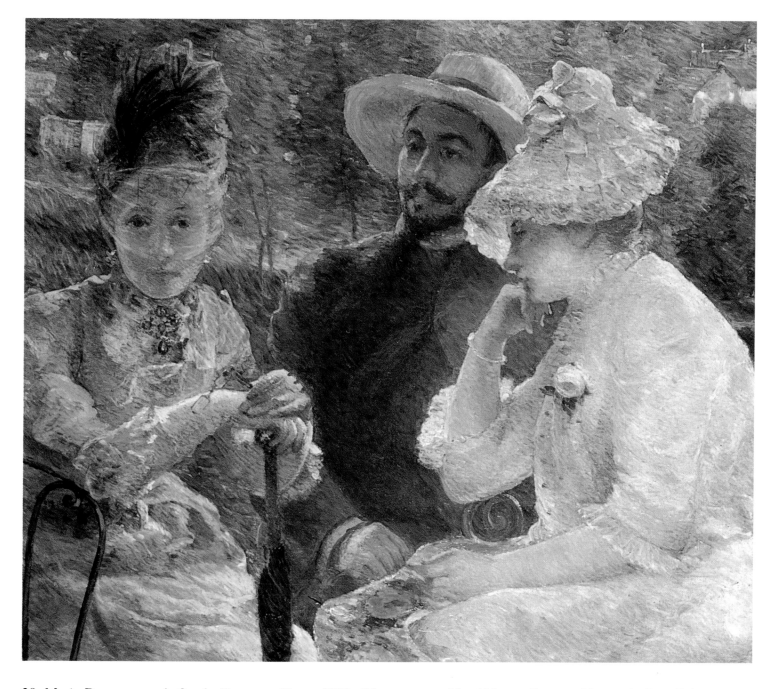

28. Marie Bracquemond. *On the Terrace at Sèvres*. 1880. Oil on canvas, 88 × 115 cm. Geneva, Musée du Petit Palais

27. Marie Bracquemond. *Woman in White*. 1880. Oil on canvas, 181 × 100 cm. Cambrai, Musée de la Ville de Cambrai

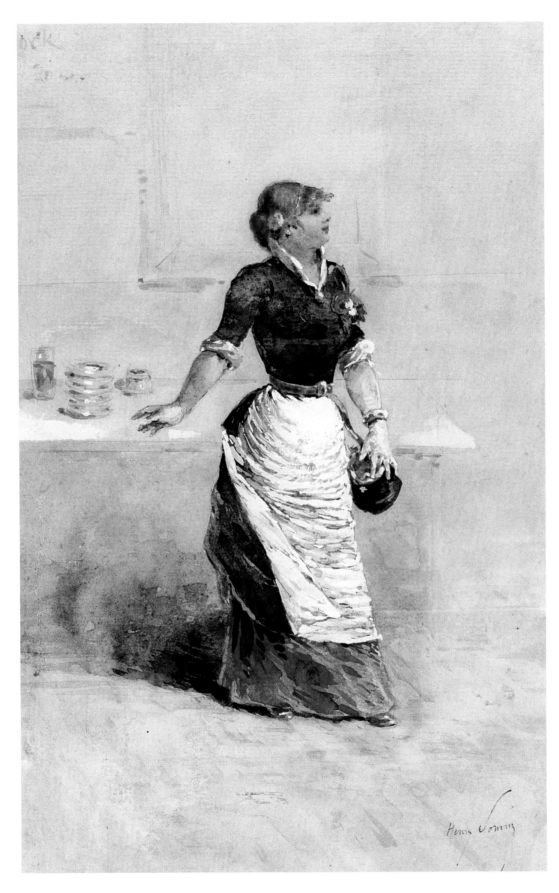

29. Henry Somm. *The Beer Waitress. c.*1875–80. Pencil, watercolour and gouache on paper, 24.2 × 15.9 cm. Private collection

30. Charles-Albert Lebourg. *Port of Algiers*. 1876. Oil on canvas, 31.2 × 47 cm. Paris, Musée d'Orsay

31. Alphonse Maureau. *Banks of the Seine*. 1877. Oil on panel, 14.5 × 24 cm. Florence, Galleria d'Arte Moderna

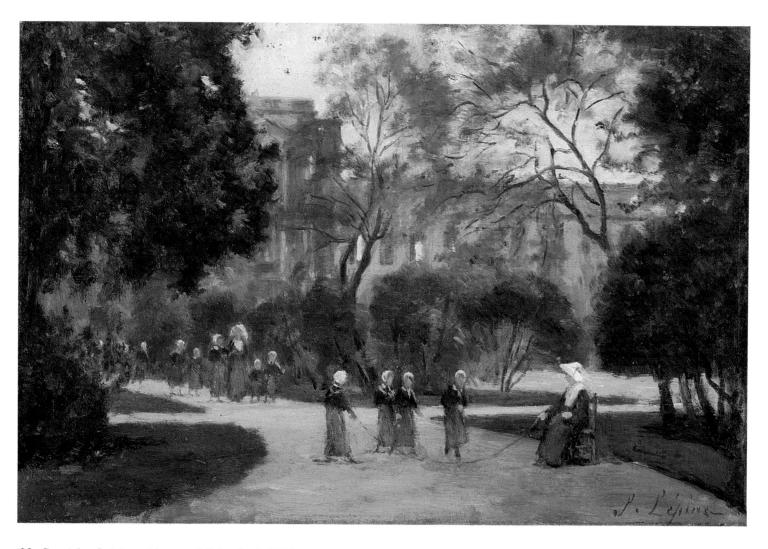

32. Stanislas Lépine. *Nuns and Schoolgirls Walking in the Tuileries Gardens. c.*1874. Oil on panel, 15.5 × 23.6 cm. London, National Gallery

33. Stanislas Lépine. *Rue Norvins at Montmartre.* 1878. Oil on canvas, 33 × 23.5 cm. Glasgow, Glasgow Art Gallery and Museum

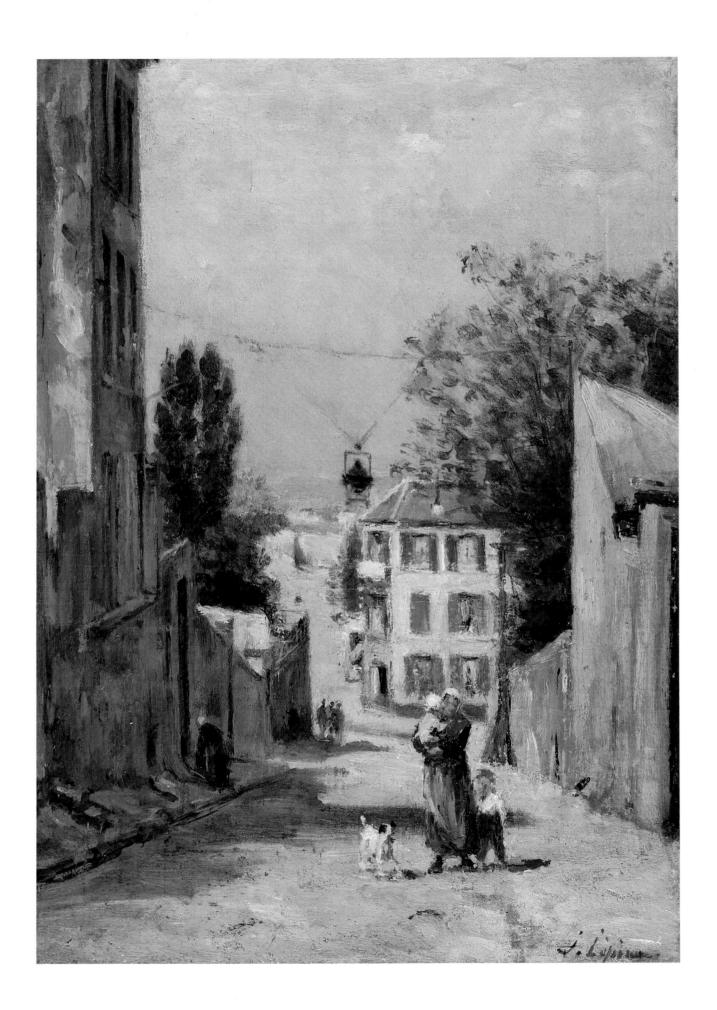

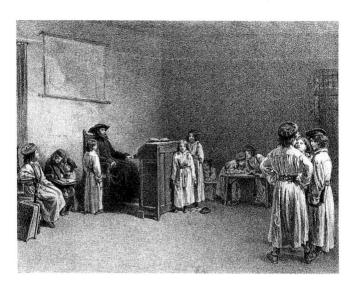

34. Edouard Brandon. *The Examination. c.*1874.
Etching. Paris, Bibliothèque Nationale, Cabinet des
Estampes

'Impressionists', a reference to Monet's painting *Impression, Sunrise* (Paris, Musée Marmottan), and the term was used to identify a new school, and to obscure the heterogeneity of the exhibitors.

One of the critics to use the term more specifically was Jules Castagnary, who believed that certain of the exhibitors, primarily Monet, Sisley, Morisot, Renoir and Pissarro were 'impressionists in the sense that they render not the landscape, but the sensation produced by the landscape.' This definition could not be extended to all the exhibitors, and by separating a particular group of the exhibitors from their fellows, it also denies that the decision to exhibit collectively was of significance.

The political implications of the collective exhibitions were evident to contemporary critics, particularly at the second exhibition held at the premises of Durand-Ruel at 11 Rue le Peletier in 1876. In general terms, critics on the right wrote negative accounts of that show, critics on the left were more inclined to praise it. The artists were often described as 'intransigents', a term which evoked the Spanish anarchists known as '*los intransigentes*'. A favourable review by the left-wing critic Blémont in *Le Rappel* was cited in a right-wing paper, the *Moniteur Universel*, with the comment: '. . . the "Impressionists" have found a complacent judge in *Le Rappel*. The Intransigents in art holding hands with the Intransigents in politics, nothing could be more natural.' Another critic, Louis Enault, also made a connection between the political Intransigents and the Intransigent painters: 'The political Intransigents admit no compromises, make no concession, accept no constitution . . . The terrain on which they intend to build their edifice must be a blank slate.' The artists, Enault claimed, had a similar wish to begin with a blank slate.

To define Impressionism on the grounds of participation or non-participation in the independent exhibitions is problematic. By such a definition, Manet, who steadfastly refused to show with them, is not an Impressionist, although contemporary writers often included him among their ranks. He moved in the same artistic circle as Degas, Monet and Renoir, and was a key member of the group which gathered at the Café de la Nouvelle-Athènes, represented by the young Forain in an etching of the mid-1870s (Pl. 26). His paintings of the 1870s display many of the same concerns as work by Monet, Morisot or Renoir, while both Degas and Forain (Pl. 4) shared Manet's fascination with the picturing of the life of the city, by day and by night.

The definition of Impressionism is further complicated if the number of occasions on which an artist participated at the group shows is considered to be significant. Can one, by this criterion, define an artist as an

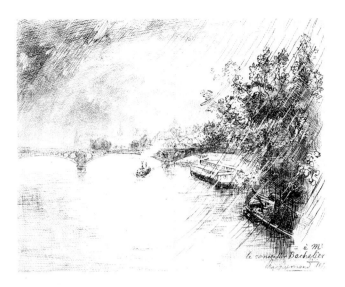

35. Félix Bracquemond. *The Saints-Pères Bridge.*
1877. Etching, 19.9 × 24.9 cm. Worcester, Mass.,
Worcester Art Museum

Impressionist on the basis of one showing only, as in the case of de Nittis, particularly if in that instance 'Impressionism' had not yet been named? While de Nittis can probably more appropriately be regarded as a naturalist painter, Impressionism itself was not an isolated phenomenon, but was part of a wider naturalist movement. If participation in more than one exhibition is a criterion, the case of Charles Tillot poses problems; he showed at six of the eight exhibitions (Pl. 9), more often than Renoir, whose work was included in only four. But both in terms of generation and of style, Tillot, born in 1825, could more readily be dubbed a Barbizon painter than an Impressionist. He first showed at the Salon in 1846 and wrote art criticism in the 1850s. In 1860 he bought a house in the Barbizon Forest and became a pupil of Millet and of Théodore Rousseau. Tillot's decision to participate in the independent shows and to continue showing in that forum means that, by some definitions, he must be regarded as an Impressionist.

Yet another difficulty of definition is raised by the case of Paul Cézanne, who contributed to the first and third shows, but who is generally described in twentieth-century art history writings in English as a 'Post-Impressionist', that label invented by Roger Fry in 1910 for his exhibition at the Grafton Gallery of 'Manet and the Post-Impressionists'. In modernist writing, Cézanne is seen to represent virtually the antithesis of Impressionism, in his preoccupation with the surface ordering of the picture, as opposed to capturing fleeting effects of natural light, yet Castagnary's definition is one Cézanne would have recognized as pertinent to his own quest for the appropriate means to realize his sensations of nature.

Of the eight exhibitions, the only one the artists themselves called an 'Impressionist' exhibition was the third, held in 1877. Even on that occasion, although the name 'Impressionist' was over the door, the catalogue was titled the 'Third Exhibition of Paintings by . . .'. If this exhibition is regarded as the touchstone of what is meant by Impressionism, we find that alongside the familiar names—Cézanne, Degas, Monet, Morisot, Pissarro, Renoir, Sisley—appear several far less well-known ones—Caillebotte, Cals, Cordey, Guillaumin, Jacques-François, Lamy, Levert, Maureau, Piette, Rouart and Tillot. This latter list outnumbers the former and provides ample evidence of the complexities of defining who was an Impressionist, and what is an Impressionist painting. Such definitions often run counter to our confident belief that this well-explored moment in art history, the subject of so many books and articles, is transparently accessible.

2 The Group Exhibitions

Many of the less well-known artists associated with Impressionism played significant roles in the organization of the eight group exhibitions. Some of them were involved from the inception in the idea of holding independent group shows; some made the exhibitions possible by their financial assistance; while the presence of others provoked the dissension and bad feeling that marked the arrangement of the fourth, fifth, sixth and seventh exhibitions. The individual artists and their works are discussed in subsequent chapters: in this chapter it is the role they played in the group shows that is the focus.

Edouard Béliard is one such figure, virtually unknown today, who was one of the original group of artists that decided that independent shows were a necessity. A friend of Pissarro, Cézanne and Zola from the 1860s, he was one of the artists referred to by Zola's friend Paul Alexis in an article in *L'Avenir National* in May 1873. Alexis discussed the idea of independent shows, which he claimed would 'inject new blood into the anaemic old world'. When Monet replied to Alexis, 'A group of painters assembled in my home has read with pleasure the article you have published', Alexis published the letter. He informed his readers that 'several artists of great merit' already constituted this group, naming Béliard among them. He recognized that the artists' intention was to initiate a new approach to the display of paintings, not a new style, and that they hoped 'all serious artists' would join them in their endeavour.

For Béliard, as for many of his colleagues, the principle of jury-free exhibitions was all-important. A founding member of the co-operative association which organized the first exhibition in 1874, he was also a member of the 'Control Committee' whose responsibility it was to prepare a financial statement after the exhibition ended. He served on this with Renoir, the landscapist Louis Latouche and the co-operative's treasurer, the sculptor Auguste Ottin. He was present when a general assembly of the members of the society was held in Renoir's studio on 17 December 1874 and it was decided unanimously that the society be liquidated.

Since the participants in the group shows did not share an aesthetic or a political position, but came together because of their disgust at the Salon system and the paucity of other outlets for the display of contemporary art, individual grievances and splits between conflicting factions soon surfaced. By 1878 Renoir had returned to the Salon; in 1879 Sisley attempted to join him but had his submission rejected; by 1880 Monet, Renoir, Sisley and Cézanne were absent from the fifth group show.

Plans had been made to hold a third group show in 1878, and Gustave Caillebotte, although he was only twenty-eight at the time, made financial provision for this show in his will, signed in 1876. Its first paragraph stated: 'It is my wish that there be taken from my estate the sum necessary to hold, in 1878, the exhibition of the painters known as Intransigents or Impressionists.' The financial recession of that year and the competition of the Universal

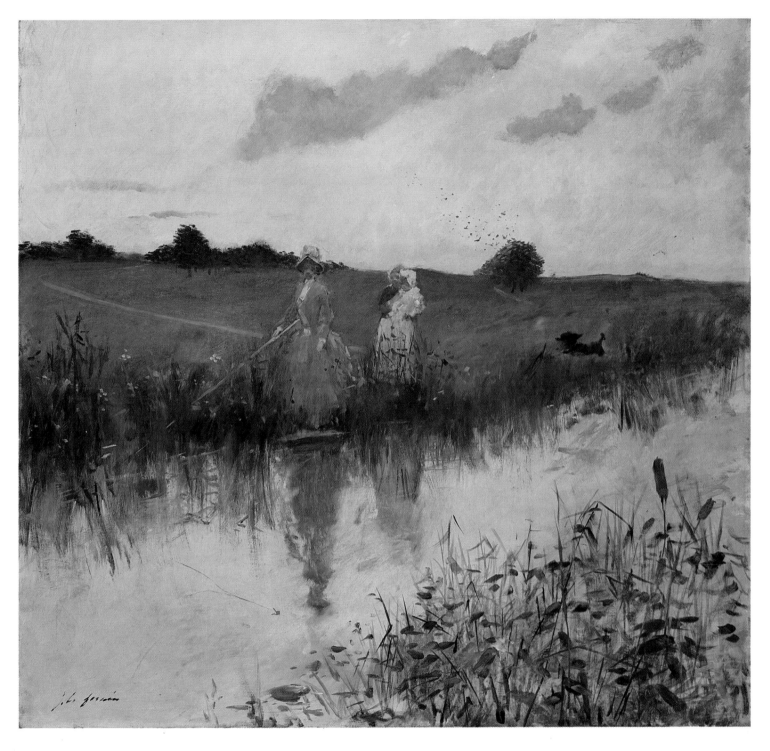

36. Jean-Louis Forain. *The Artist's Wife Fishing.* 1879. Oil on canvas, 95.2 × 101.3 cm. Washington, D.C., National Gallery of Art, Collection of Mr and Mrs Paul Mellon

Exhibition, which opened on 1 May, made some artists sceptical about the wisdom of holding a group show. Pissarro reported to Caillebotte that Degas had claimed: 'An exhibition now would be a flop, because all the crowds go to the Champ de Mars [site of the Universal Exhibition].'

The 1878 exhibition did not materialize, but when plans were revived early in 1879 Caillebotte played a central role in the negotiations. He attempted to convince the strongest possible group of painters to show, and was successful in persuading a reluctant Monet to participate, although Renoir, Sisley, Cézanne, Guillaumin and Morisot all declined. After hurried arrangements made largely by Caillebotte, Degas and Pissarro, the exhibition opened at 28 Avenue de l'Opéra on 10 April. It was billed as the 'Fourth Exhibition of a Group of Independent Artists', the only time that the word 'independent' was used in the exhibition publicity. Caillebotte was able to report to Monet after the first day: 'We are saved. By five o'clock this evening receipts were more than 400 francs.'

The fourth exhibition showed the work of several newcomers, among them Mary Cassatt, Marie Bracquemond, Paul Gauguin, Federico Zandomeneghi and Jean-Louis Forain. Marie Bracquemond had been a pupil of Ingres, but she was a recent convert to *plein-air* painting, much to the dismay of her husband, the etcher Félix Bracquemond, who opposed Impressionist methods. Mary Cassatt had been invited to participate in the group exhibitions by Degas in 1877, and had accepted the invitation with enthusiasm. Forain (Pl. 36) and Zandomeneghi (Pl. 39) had also been recruited by Degas. Gauguin had been invited to participate at Pissarro's instigation. By the following year Degas and his group of friends were being seen as a threatening faction by certain other participants, notably Caillebotte.

Caillebotte continued to play a major role in the organization of the 1880 exhibition, although disagreements between him and Degas frequently surfaced. A particular source of contention was publicity. Degas wrote angrily to Félix Bracquemond: 'The posters will be up tomorrow or Monday. They are in bright red letters against a green background. There was a great fight with Caillebotte about whether or not to publish names. I had to give in to him and allow them to appear. When will there be an end to this star billing? . . . Next year I shall surely arrange it so that this doesn't continue. I am upset, humiliated.'

Degas had introduced further recruits to the group show's ranks in 1880, including Jean-François Raffaëlli, who showed thirty-five paintings, and his brother Jean-Marius Raffaëlli, who exhibited a group of etchings. Another newcomer in 1880 was Victor Vignon, one of the group of painters who worked with Pissarro at Pontoise. The critics were quick to notice that some of the work at this group show was not markedly different from canvases on view at the Salon: Charles Ephrussi, for example, commented that much of the work appeared to have 'emigrated' from the Salon and that there was little to differentiate it from 'the four thousand canvases' on view there.

By 1881 the divisions between various factions were so extreme that Caillebotte wrote to Pissarro:

What is to become of our exhibitions? This is my well-considered opinion: we ought to continue, and continue only in an artistic direction, the sole direction—in the final sense—that is of interest to all of us. I ask, therefore, that a show should be composed of all those who have contributed real interest to the subject, that is, you, Monet, Renoir, Sisley, Mme Morisot, Mlle Cassatt, Cézanne, Guillaumin; if you wish, Gauguin, perhaps Cordey, and myself. That's all, since Degas refuses a show on such a basis . . . It's very naive of us to squabble over these things. Degas introduced disunity into our midst.

Caillebotte objected particularly to the presence of Raffaëlli, whose work he felt had no place at the group shows but belonged at the Salon.

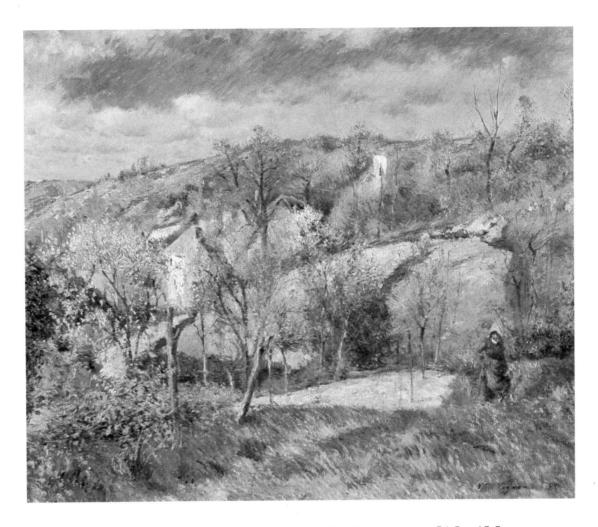

37. Victor Vignon. *Peasant Woman in the Fields*. 1882. Oil on canvas, 54.5 × 65.5 cm. Aix-les-Bains, Musée du Docteur Faure

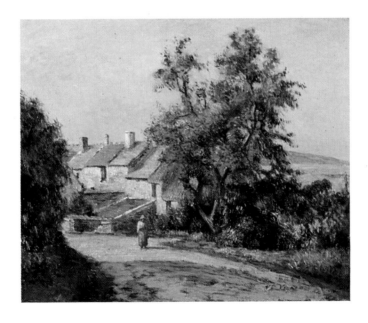

38. Victor Vignon. *Road by the Cottages*. c.1882. Oil on canvas, 33 × 41 cm. Aix-les-Bains, Musée du Docteur Faure

39. Federico Zandomeneghi. *Fishing on the Seine*. 1878. Oil on panel, 15 × 25 cm. Florence, Galleria d'Arte Moderna

40. Paul Gauguin. *Landscape at Saint-Cloud (Near the Farm)*. 1885. Oil on canvas, 55.9 × 100.3 cm. Portland, Maine, Joan Whitney Payson Gallery of Art, Westbrook College

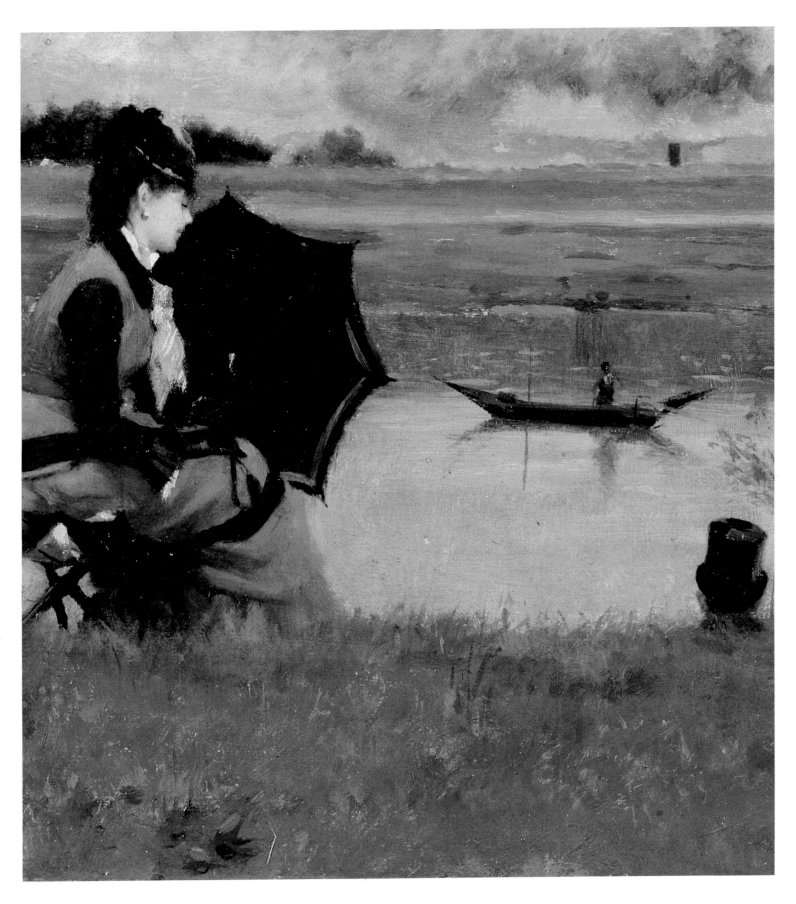

41. Federico Zandomeneghi. *Fishing on the Seine* (detail of Pl. 39)

Caillebotte and Degas could not resolve their differences, and Caillebotte withdrew from the 1881 exhibition. Late in 1881 Gauguin wrote to Pissarro:

Last night Degas told me in anger that he would hand in his resignation rather than send Raffaëlli away. If I examine calmly your situation after ten years during which you undertook to organize these exhibitions, I immediately perceive that the number of impressionists has progressed, their talent increased, their influence too. On Degas's side . . . the tendency has been getting worse and worse: each year another impressionist has left and been replaced by nullities and pupils of the École. Two more years and you will be left alone in the midst of these schemers of the worst kind.

When Caillebotte began planning a seventh group show, he attempted to persuade Degas that Raffaëlli had no right to participate. However, as Caillebotte informed Pissarro, 'Degas won't give up Raffaëlli for the simple reason that he is asked to, and he'll do it all the less, the more he is asked to do so.'

Raffaëlli's inclusion points to the fact that there is no simple way of defining 'Impressionist'. While his work has virtually nothing in common with, for example, that of Morisot, by exhibiting in the same forum they could be regarded as part of the same movement. It was to avoid such categorization that Monet dissociated himself from the blanket term 'independents' and insisted, in an interview in 1880, that he was still and always intended to be an 'Impressionist'.

Some painters benefited from the rifts that divided the original participants in the group shows. Vignon, for example, was able to show fifteen canvases in 1882 (Pls. 37, 38) because of Pissarro's support, presumably since neither his work nor his personality aroused strong antagonism. Paul Durand-Ruel undertook to arrange the exhibition himself, but the doubts and uncertainties continued. Pissarro wrote to Monet: 'For two or three weeks now I have been making great efforts—in conjunction with our friend Caillebotte—to arrive at an understanding in order to reassemble our group as homogeneously as possible.' Renoir, ill with pneumonia at L' Estaque, directed his resentment against the politics of Pissarro and his friends, and particularly against Guillaumin. In a draft of a letter to Durand-Ruel on 26 February 1882 he wrote: 'For me to exhibit with Pissarro, Gauguin and Guillaumin would be like exhibiting with any Socialist. The next thing you know Pissarro would invite the Russian Lavrof [the anarchist Pierre Lavroff] or some other revolutionary.' A few days later, Renoir wrote: 'I hope these gentlemen will give up the idiotic name "Independent". Please tell these gentlemen that I am not giving up the Salon. It is not a pleasure, but as I told you, this removes me from the revolutionary aspect, which scares me. . . . If I exhibit with Guillaumin, I might just as well exhibit with Carolus-Duran [the Salon portraitist]. I don't much see the difference' For Renoir, Guillaumin was tainted not only by his politics, but by the similarities between his painting and the work on view at the Salon.

When the seventh exhibition finally opened in March 1882 at 251 Rue St-Honoré, it did so without Degas and his friends being represented. Henri Rouart had personally paid the rent for the premises, but withdrew his paintings in support of Degas. Raffaëlli also withdrew. Cassatt supported Degas, and she was opposed to the intervention of a dealer: she too was absent from the show. Despite the truncated list of participating artists, Eugène Manet reported to his wife Berthe Morisot that the critic Théodore Duret 'says that this year's exhibition is the best your group has ever had.'

By 1886, when the eighth and last group show was held, the Parisian art world was very different from how it

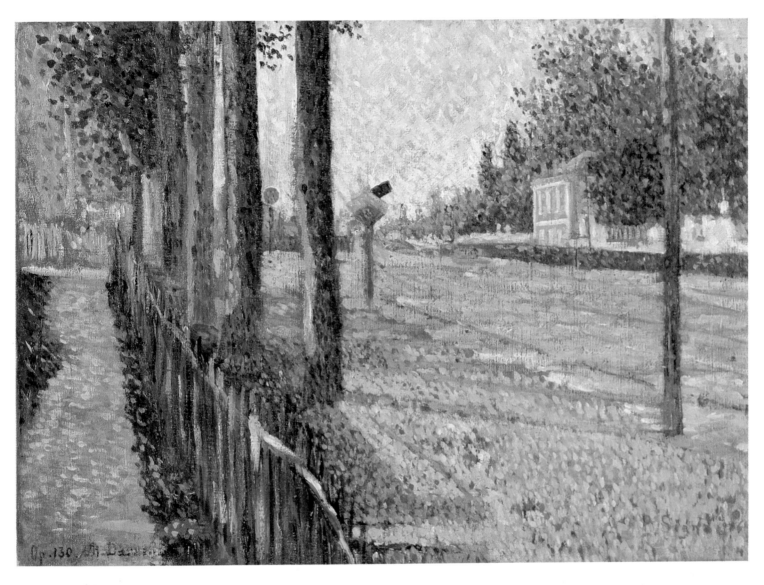

42. Paul Signac. *The Railway Junction at Bois-Colombes*. 1886. Oil on canvas, 33 × 47 cm. Leeds, Leeds City Art Gallery

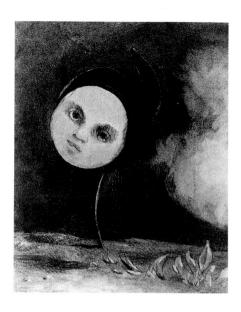

43. Odilon Redon. *The Marsh Flower*, illustration from 'Hommage à Goya'. 1885. Lithograph on paper, 27.5 × 20.5 cm. London, British Museum

had been in 1874. Now it was independence from the dealers rather than from the Salon that was sought by some of the participating artists, notably Pissarro, Guillaumin and Vignon. Guillaumin noted in a letter to Pissarro that the exhibition was to be made 'completely independent without the intervention of dealers and with the conditions that [participants] cannot send to the Salon or to the exhibition of a dealer like Petit [the fashionable dealer Georges Petit, Durand-Ruel's great rival in the 1880s]'. Guillaumin's dislike for any form of jury selection had led to his association with the Société des Indépendants, founded in 1884, with whom he showed in the summer of 1886, after the final group show. His distaste for the increasingly lavish premises of dealers like Petit, whose gallery Zola described as 'the department store of painting', is indicated by Pissarro's comment to his son Lucien in a letter of 1886: 'I agree with Guillaumin and his friends, the Petit gallery is a grandiose place for an exhibition.' But Guillaumin and his friends, such as Vignon, who constituted a group Pissarro referred to as *Guillaumin et Cie*, were opposed not only to dealer shows and to Degas and his group, but also to Pissarro's new associates, Georges Seurat and Paul Signac (Pl. 42).

Pissarro's determination that Seurat and Signac be included among the ranks of the participants in the final group show led to further disputes. Pissarro observed bitterly: 'It seems that the old group will close ranks; as for me, I insist on the right to go my own way.' By 1886 Morisot, Guillaumin and Gauguin were regarded by critics as the only representatives of Impressionism in the exhibition, which included work by Odilon Redon (Pl. 43), better known as a symbolist. Octave Maus, writing for the Brussels journal *L'Art Moderne*, perceived Gauguin as 'following in Guillaumin's path', while the connection with Pissarro was picked on by the critic Marcel Fouquier in *Le XIXe Siècle*: 'Gauguin, Guillaumin, Schuffenecker, Vignon, and Signac, newcomers to Impressionism, like all new converts are consumed with a fine ardour, a burning desire to go further than anyone and to make Pissarro stop, bemused, in front of their canvases. None of them lacks talent, as Gauguin's landscape *Near the Farm* (Pl. 40) proves well enough.' What was evident, too, was that the combination of a changing art market and the splitting and fragmentation of the interests of the participants made the organization of further group shows an impossibility.

3 Pontoise and Pissarro

Several of the exhibitors at the first and subsequent group exhibitions were associated with Camille Pissarro and the area around the market town of Pontoise, on the river Oise, some thirty kilometres northwest of Paris. Pissarro had lived in Pontoise between 1866 and 1868, and returned to the town in 1872 after the Franco-Prussian war. The town attracted him partly because of the varied surrounding landscape, but partly also because of its accessibility to Paris after the establishment of the railway link in 1864. This ease of access to the city was important in many ways: to maintain contacts with friends and to participate in the lively exchange of views and ideas at the cafés; to visit exhibitions and ensure a familiarity with the fast-changing Paris art world; and above all, to find a market for paintings. Paris was the centre of the world art market at this time. It was in Paris that Pissarro and other members of the group made their often weary rounds of the few collectors who were known to be interested in their work, since it was only there that paintings of all kinds, including those of rural scenes, could be sold.

The landscape of the Oise valley offered a variety of potential motifs, riverscapes, cliffs and hills, wheatfields and large gardens, but Pontoise itself had not attracted the attention of many artists before Pissarro settled there. It was the nearby town of Auvers, some six kilometres away, which was the haunt of painters: Daubigny had painted there from 1860, and settled in the nearby hamlet of Villiers-de-l'Isle-Adam in 1864; he was visited by many painters, including Corot and Daumier. Despite Pontoise's proximity to Paris, it was emphatically not a suburb of the city, but a distinct provincial town. Its rural aspect appealed to Pissarro, and he soon gathered around him a group of like-minded painters. Many of them wished to learn from Pissarro's example, as he had learned from Corot's, and they watched him at work, often *en plein air*, and discussed ideas about art. Like Corot, who had made a singular exception for the Morisot sisters, Berthe and Edma, Pissarro did not have formal pupils, but he believed in co-operation and never stinted in his efforts to encourage other painters.

To the circle around Pissarro individuality was crucially important. They spent many hours discussing the concept of the '*sensation*', each artist's unique vision of nature, vital in their view to painting. One of the ways of stressing the importance of '*sensation*' was to claim that all conventions of art had been rejected. This was the sense in which Emile Blémont defined Impressionism when he wrote in *Le Rappel* in 1876 that the Impressionists strove to 'render with absolute sincerity, without arrangement or attenuation, by simple and broad techniques, the impression that aspects of reality evoked in them. . . . And as there are probably no two men on earth who perceive the same relationships with the same object, [they] do not need to modify their personal and direct sensation according to any convention whatever.'

One of the first artists to join Pissarro at Pontoise was Edouard Béliard. Béliard was born in 1834 in

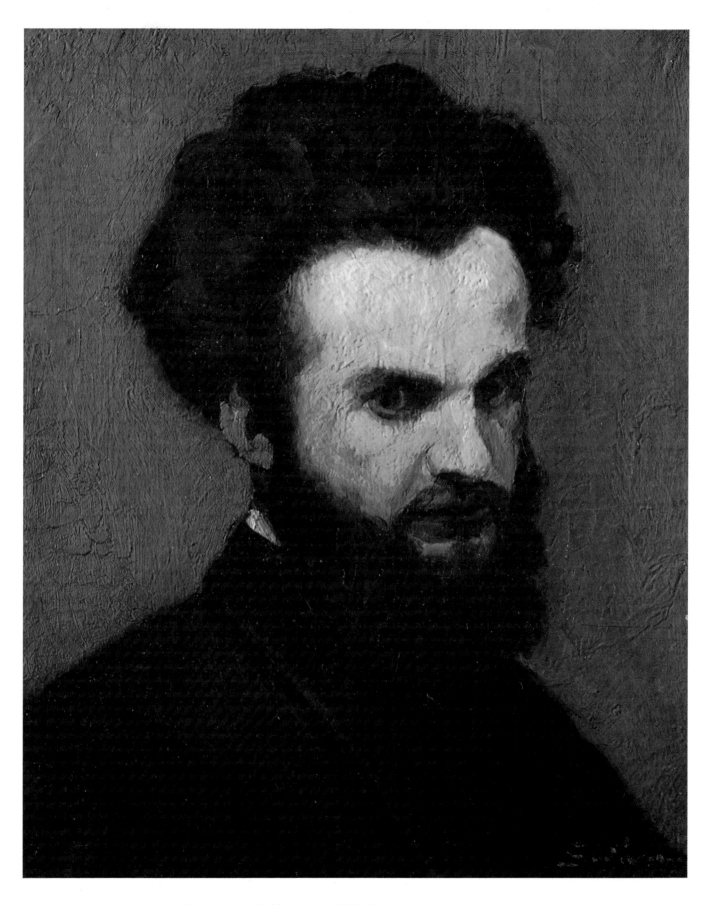

44. Jean-Baptiste-Armand Guillaumin. *Self-portrait*. 1878. Oil on canvas, 45.4 × 37.8 cm. Cleveland, Ohio, Cleveland Museum of Art, Bequest of Noah L. Butkin

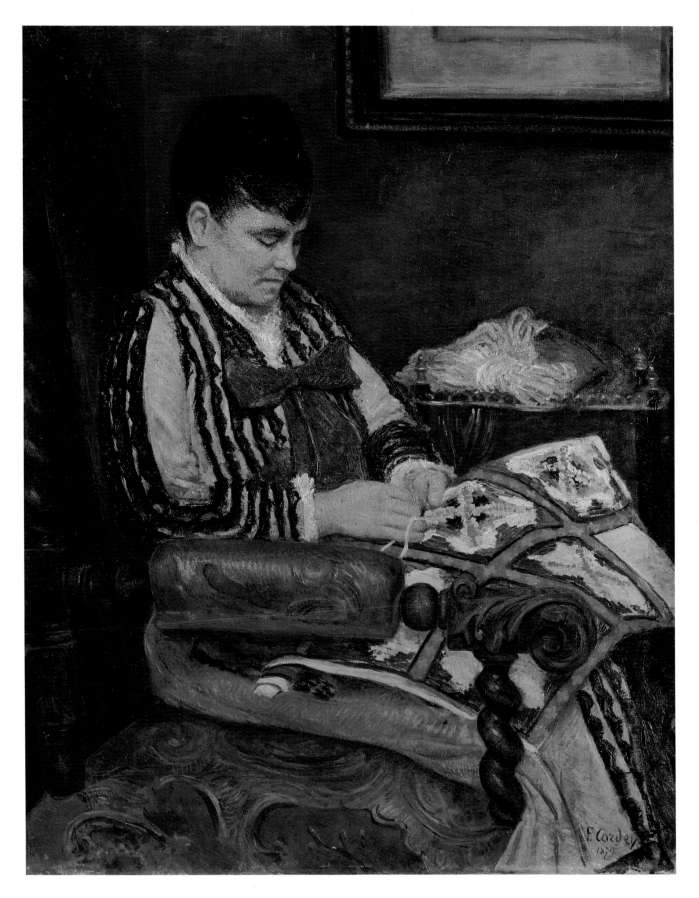

45. Frédéric Cordey. *Portrait of Mme Cordey*. 1879. Oil on canvas. Paris, Musée d'Orsay

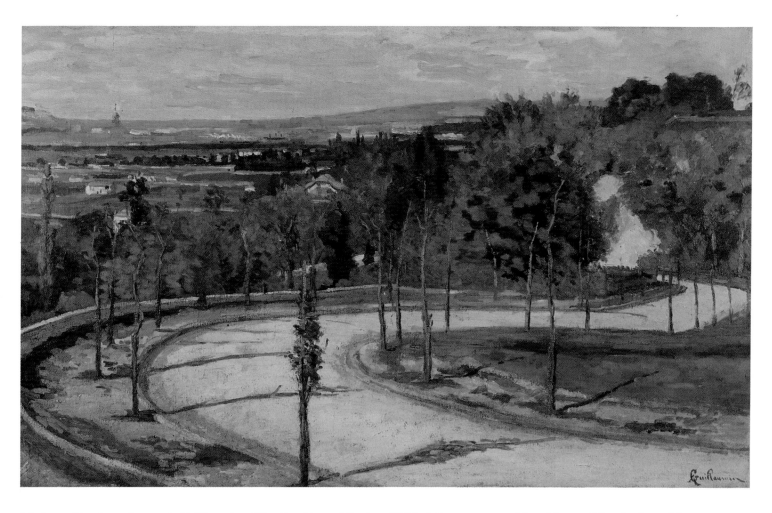

46. Jean-Baptiste-Armand Guillaumin. *The Outskirts of Paris. c.*1874. Oil on canvas, 60 × 81 cm. Birmingham Museums and Art Gallery

47. Victor Vignon. *Pontoise Landscape. c.*1882. Oil on canvas, 48.5 × 80.7 cm. Bremen, Kunsthalle

Pontoise in 1873. Born in 1847, he was the son of the sculptor and writer Mme Claude Vignon. Vignon had in common with several other members of this group the fact that his early training was under Corot's guidance. Corot' informally imparted advice stressed the importance of studying tonal values. He told Pissarro: 'We do not see in the same way; you see green and I see grey and blonde. But that is not a reason for you not to consider values. No matter how one perceives or expresses things, there is no good painting without them.' Vignon's work indicates that he had taken similar lessons to heart (Pls. 47, 51). The Pontoise group's discussions about aesthetics often followed similar lines to those of Corot. Lucien Pissarro recalled his father saying, 'The important thing is not to paint a face or a figure, but to paint harmonies'—a remark which Corot could also have made.

Vignon studied Pissarro's paintings, and emulated their structuring, handling and palette, gradually moving away from the feathery brushstrokes used by Corot. The compositions of some of his paintings also changed, favouring a panoramic view similar to that employed by Cézanne in some of his Auvers landscapes. Even in a panoramic sweep of the valley and hills beyond, such as *Peasant Woman in the Fields* (Pl. 37), Vignon included a figure to give scale and to indicate the human presence in the landscape, in much the same way as Corot and Pissarro did, and, in paintings like *Road by the Cottages* (Pl. 38), the perspective effect created by the curving path, the framing device of the trees on either side and the introduction of the small figure on the path are strongly reminiscent of Corot. It was this which led Eugène Manet, Morisot's husband, to comment in his report to her on the 1882 independent exhibition: 'Vignon had relapsed into his imitations of Corot, an unfortunate influence. The unhappy boy looks quite sad and is aware of his inferiority.'

Frédéric Cordey was only nineteen when he first came to Pontoise. He was a friend of Dr Paul Gachet, the homeopath and amateur artist, and in 1875 became part of Renoir's close circle. Renoir included him in his *Scene in Renoir's Studio, Rue St Georges* (private collection), together with Pissarro and Georges Rivière, a journalist and later Renoir's biographer. Cordey accompanied Renoir on his first visit to Algeria in March and April 1881, and he often served as his model. Jean Renoir recalled his father's pleasure at Cordey's observation that painters, like gymnasts, had to remain fit, and that an essential requirement was strong legs for going into the countryside in pursuit of suitable motifs.

Cordey only showed once with the independents, at the third exhibition (Pl. 45). In 1881 Caillebotte mentioned in a letter that he was willing to consider Cordey among the exhibitors at the sixth show, but Cordey's trip to Algeria meant that he chose not to participate. Cordey remained on cordial terms with Pissarro, whom he visited at Eragny, and with Degas, with whom he worked at Saint-Valery-sur-Somme in the summer of 1898.

Jean-Baptiste Armand Guillaumin (Pl. 44), born in 1841, met Pissarro and Cézanne at the Académie Suisse in the early 1860s. After the Franco-Prussian War he was employed by the Administration des Ponts et Chaussées, but managed to spend some time working with Pissarro, Cézanne, Béliard, Cordey and Vignon in Pontoise. Pissarro told Guillemet: 'Guillaumin has just spent several days at our house; he works at painting in the daytime and at his ditch-digging in the evenings, what courage!' One of these paintings is the autumnal *The Outskirts of Paris* (Pl. 46), which shows an affinity to paintings produced by Pissarro and Cézanne during this period. At the first independent exhibition, Guillaumin showed three works, one of which was *Sunset at Ivry* (*Frontispiece*). The dramatic colour effects of *Sunset at Ivry* anticipate the often lurid palette of his later work. Another exhibit was titled *Rainy Weather*, which may be identified with Pl. 54. This subject, the quays along the Seine, was a favoured motif of Guillaumin's who lived on the Quai d'Anjou, on the Île St-Louis, in the mid-1870s (Pl. 52).

In 1881 at the sixth exhibition Guillaumin's style had changed, but the combination of violent colour effects

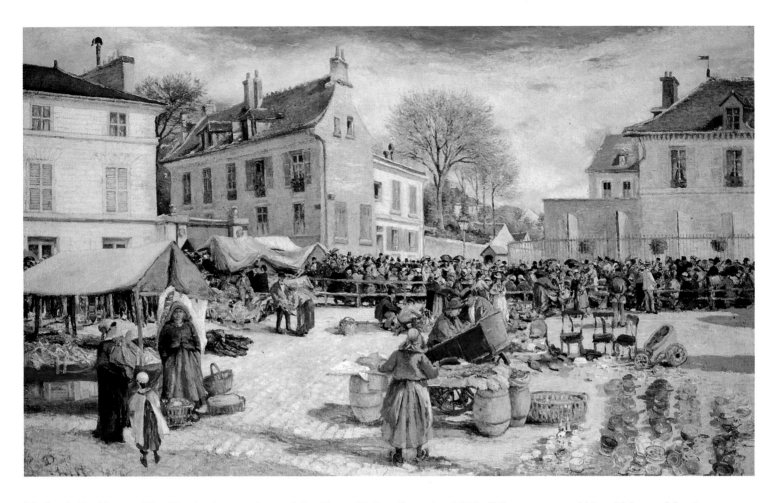

50. Ludovic Piette. *The Marketplace in front of the Town Hall at Pontoise*. 1876. Oil on canvas, 111 × 186 cm. Musée Pissarro à Pontoise

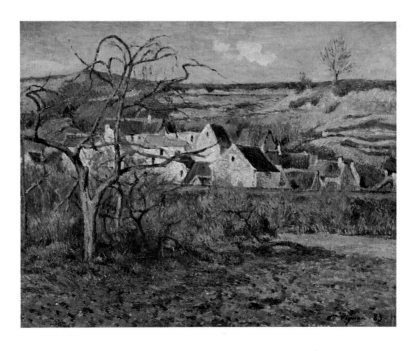

51. Victor Vignon. *The Côte Saint-Nicolas at Auvers*. 1883. Oil on canvas, 35.5 × 44.3 cm. Copenhagen, Ny Carlsberg Glyptotek

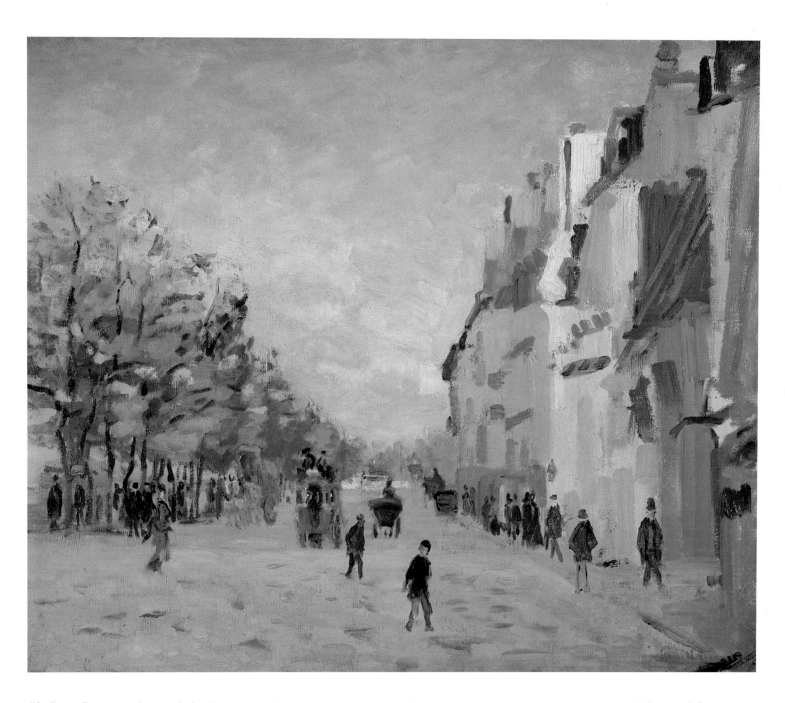

52. Jean-Baptiste-Armand Guillaumin. *Place Valhubert, Paris. c.*1875. Oil on canvas, 65 × 81 cm. Paris, Musée d'Orsay

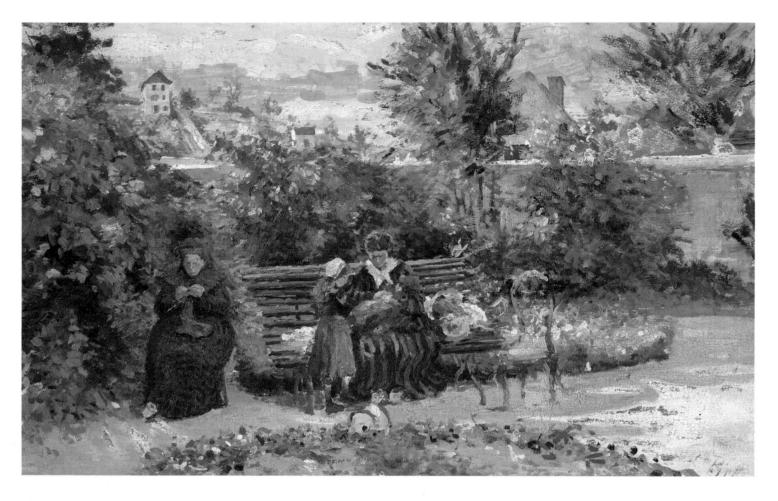

53. Ludovic Piette. *Garden of the Hermitage, Pontoise. c.*1879. Gouache on paper, 29 × 48 cm. Private collection

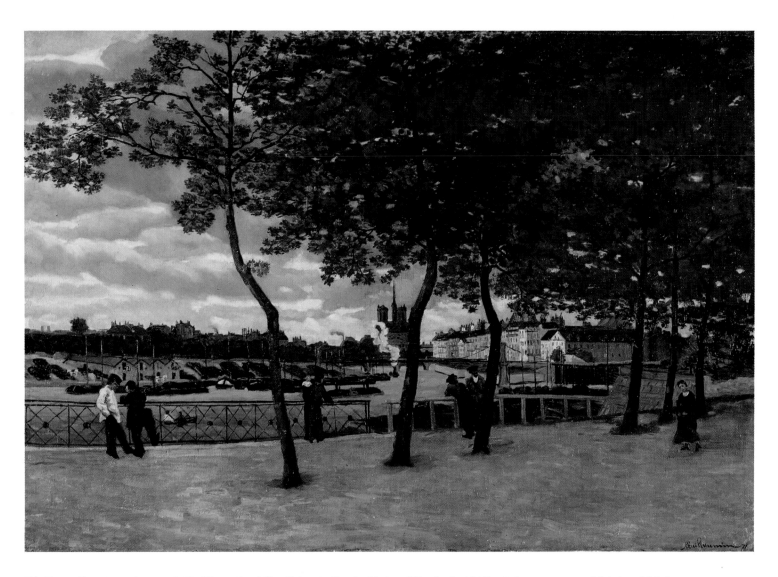

54. Jean-Baptiste-Armand Guillaumin. *The Seine in Paris (Rainy Weather)*. 1871. Oil on canvas. 126.4 × 181.3 cm. Houston, Texas Museum of Fine Arts

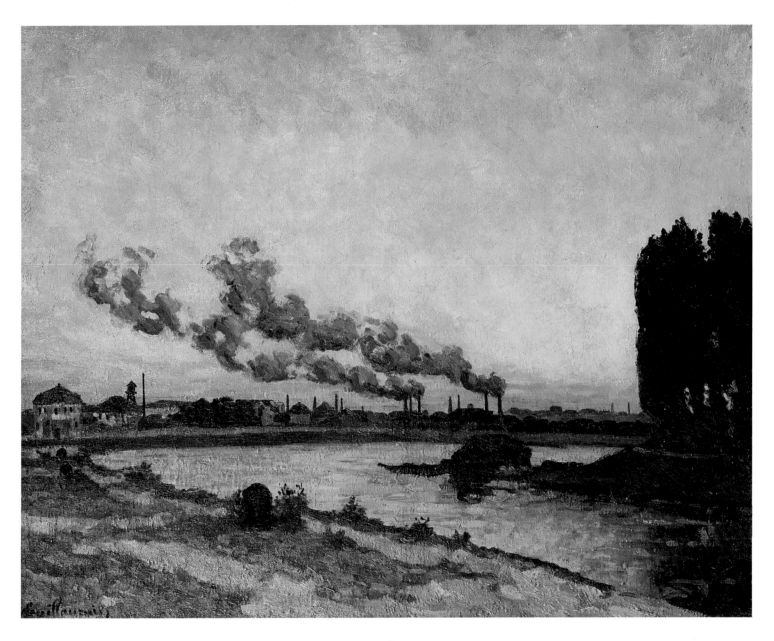

55. Jean-Baptiste-Armand Guillaumin. *Sunset at Ivry*. 1873. Oil on canvas, 65×81 cm. Paris, Musée d'Orsay

and the preference for Paris quay scenes led the critic Gustave Geffroy to remark: 'This artist treats Paris as if it were Venice. His quays and his Seine riverbanks make one think of the Grand Canal seen by an over-excited colourist . . . he accumulates little spots of green, blue, pink, orange, lilac, violet, red, yellow. . . . But these spots come together to confuse and erase everything. In our opinion this constitutes an innovation that merits no further encouragement. In general, in these landscapes it is always noon in July.'

One of Pissarro's closest friends was Ludovic Piette, who lived on an estate at Montfoucault, in the Mayenne district of Brittany, and also had a studio in Paris. Pissarro and Piette met in the early 1860s, and Pissarro often visited Piette in Brittany, using these visits as a refuge from the pressures of the city. When Pissarro settled in Pontoise, the visits betweeen the two friends were reciprocal, and Piette was attracted to the scenes of marketplaces, local fairs and the gardens of the Hermitage quarter; in *The Marketplace in front of the Town Hall at Pontoise* (Pl. 50) Pissarro himself is represented on the left, recognizable by his long beard, while *Garden of the Hermitage* (Pl. 53) resembles Pissarro's work in subject matter, colour and handling. Like Duret, Piette was well aware that the provincial bourgeoisie did not buy progressive painting. He wrote to Pissarro: 'Keep trying to find patrons, my dear Pissarro. The bourgeois of Paris are still buying. They are not like these rich idiots who live in the country. Not a painting, statue or bust can be sold here. They are as crude as peasants, and as ignorant.'

Piette did not participate in the first group show, but he wrote to Pissarro: 'And you, my poor old fighter, young in spirit despite your hair turned white too early, what has become of your attempt so well begun, I mean your association and your exhibition? I want to know about your financial success since you were assured of the other.' He was persuaded by Pissarro to join the group for the third show, despite his resentment that Monet and Renoir had not attended his one-man show in Paris. He wrote to Pissarro: 'The gentlemen of our association have not appeared (except for Cézanne and Guillaumin). If you had been here, I am sure you would have come. Why? Because, apart from your friendship, a feeling of solidarity would have prompted you to do so. Since we wish to fight against a common enemy, we should enter into a sincere pact.'

When the exhibition opened in April 1877, there were thirty-one works by Piette among the exhibits, but Piette himself died in that month. One of the critics, Louis de Fourcaud, noted: 'He is partial to marketplaces. I have counted ten in his exhibition . . .', while Paul Sébillot commented: '. . . Piette is a very serious artist who would do well not to exaggerate his Impressionism.' As a mark of respect, some of Piette's watercolours were included in the fourth exhibition in 1879.

Pissarro was the focus for the group who lived in Pontoise or Auvers, or who visited it regularly, but his role was not solely that of leader or teacher. He provided encouragement, but he also relied on his friends for support. So in 1874, when he expressed his doubts to Guillaumin, Guillaumin replied: 'Your letters are truly distressing, even more than your pictures which you say are so gloomy. What makes you always doubt yourself? You should rid yourself of this affliction. I know very well that times are hard and that it is difficult to look at things gaily, yet you should not give in to despair just when things are about to turn for the better.' When Guillaumin, in his turn, was depressed about his work, he wrote: 'I am very anxious to see you and above all to talk to you. I feel that a few moments with you would cheer me up.' Pissarro had a gift for emphasizing the strong points in other artists' work and for giving them confidence. His position as a kind of father figure for Impressionism was established later in his career, particularly in the 1890s. Cézanne later commented: 'Pissarro was like a father to me: he was a man you turned to for advice, and he was something like the good Lord.'

Cassatt said of Pissarro that he was such a teacher, he could have taught stones to draw correctly, and one

57. Lucien Pissarro. *The Pastrycook.*
*c.*1884. Woodblock on paper,
13.6 × 6.2 cm. Oxford, Ashmolean
Museum

56. Lucien Pissarro. *The Curé. c.*1884.
Woodblock on paper, 8.8 × 8.3 cm.
Oxford, Ashmolean Museum

younger painter whom Pissarro undoubtedly did teach was his son Lucien. Born in 1863, Lucien moved to London when he was twenty, and his father corresponded with him regularly, advising him about his art practice and commenting on his own activities and the events of the Paris art world. Lucien returned to France in the spring of 1884, to study wood engraving under Lepère. He then joined the firm of Manzi to learn the process of printing colour blocks. Four of his illustrations to a story by Octave Mirbeau were published in *La Revue Illustrée*, and earlier in the same year, when arrangements for the eighth group show were being discussed, Pissarro succeeded in having Lucien invited to participate. He also showed in the Salon des Indépendants in August and September of the same year, after spending the summer at Le Petit Andely, on the Seine, with Paul Signac. The drawing for *The Curé* (Pl. 56) was one of a series made to illustrate the verses, *Il était une bergère.* The wood engraving appeared in the magazine published by Georges Charpentier, *La Vie Moderne*, in 1887. *The Pastrycook* (Pl. 57) may represent the son of the pastrycook Eugène Murer, a collector of Impressionist paintings. It is signed 'L. Vellay', because at this time Lucien used his mother's name to avoid confusion with his father.

In the 1870s the Pissarro household at Pontoise served as the equivalent to the Paris cafés: a place to debate artistic ideas and theories, to discuss plans for exhibitions and to comment on colleagues' work. The subsequent prominence accorded to Impressionism has assigned Pissarro a position as a key figure, formulating single-handed one aspect of Impressionism in Pontoise while Renoir and Monet forged another strand at Argenteuil. But as Pissarro told Lucien: 'I didn't conceive, even at forty [in 1870], the deeper side of the movement we followed instinctively. It was in the air!'

4 The Artist-patrons

Edmond Duranty wrote in 1876 in his essay *The New Painting: Concerning the Group of Artists Exhibiting at the Durand-Ruel Galleries*: '. . . it matters very little whether the public understands. It matters more that the artists understand. For them one can exhibit sketches, preparatory studies, and preliminary work in which the thought, intention, and draughtsmanship of the painter often are expressed with greater speed and concentration. In this work one sees more grace, vigour, strength, and acute observation than in a finished work.' The fellow artists who could appreciate the most daring work on display were also sometimes patrons, valued the more because they purchased paintings which dealers would have refused.

Among these artist-patrons, Henri Rouart was one of the most loyal supporters of the independent exhibitions, showing in seven of them. He and Degas had attended the same school, the Lycée Louis-le-Grand, and Rouart had then been a student of higher mathematics at the École Polytechnique. He held patents for various mechanical inventions and had made a sizeable fortune as a pioneering manufacturer of vapour-compression machines for refrigeration. He had also invented apparatus for transmitting telegrams. While he pursued his career as an inventor and entrepreneur, he was an enthusiastic amateur painter. Like many other participants in the group exhibitions, he had been advised by Corot, and he sometimes worked at Millet's side in the forest of Fontainebleau.

Rouart had already begun to amass a collection of paintings when he renewed his early friendship with Degas during the siege of Paris in 1870, but after the war his importance as a patron of contemporary art quickly established his position within the independents' circles. He bought from Durand-Ruel, but also from the dealer Père Martin, whose regular clientéle were generally of far more modest means than Rouart. His collection filled his house at 34 Rue de Lisbonne, as both his *Portrait of Madame Rouart* (Pl. 59) and Degas's portrait of his daughter (Pl. 60) indicate. Like her daughter in Degas's portrait, Madame Rouart is surrounded by her husband's possessions: books, vases, a bust on the mantelpiece, pictures on the wall. When Rouart died in 1912 his collection included fifty-three works by Corot, fifteen by Delacroix and fifteen by Degas, as well as others by El Greco, Goya, Chardin and Fragonard, Greek classical fragments, Egyptian funerary statues and Chinese wall-hangings.

Unlike Degas, Rouart was always a landscapist and *plein-air* painter. His work was strongly influenced by Corot's example, and critics who commented on his paintings tended to note its difference from much of the other work on display. In 1880, when he showed *Terrace on the Banks of the Seine at Melun* (Pl. 63), Armand Silvestre commented: '. . . you would have to be extremely clever to find in it any revolutionary or reforming instincts.' The freely worked *Young Woman Reading* (Pl. 62) does bear a resemblance to Morisot's work (Pl. 61), perhaps in part because neither artist was compelled to finish work to the standards dealers found acceptable.

Vicomte Ludovic-Napoléon Lepic was another of Degas's friends who was recruited for the first

independent exhibition because he was potentially a patron as well as a painter. Lepic was a man of many parts: he had studied painting with Gleyre and Cabanel, and was also an engraver and a sculptor. An enthusiastic sportsman, he was a gentleman jockey and a breeder of greyhounds. He was also an amateur archaeologist, who had written and illustrated a volume on prehistoric weapons and tools, which was published in 1872. Like Degas, he was a balletomane, and in 1874 he and Degas collaborated on a monotype, Degas's first venture in this medium, of the ballet master Jules Perrot. An ardent Bonapartist, Lepic named his daughter Eylau after the battle of 1807, and he would have had scant sympathy with the more radical independents. Nonetheless, after showing four watercolours and three etchings at the first exhibition, he remained with the independents for the second show in 1876, exhibiting thirty-six items. It was perhaps the hostility of the conservative press to this exhibition that prompted his withdrawal from subsequent shows.

Gustave Caillebotte was in many ways a central figure in Impressionism, in his roles as collector, organizer of exhibitions and painter. Although he can no longer be said to be truly 'unknown', since there has been considerable interest in him in the last decade, his position as a painter whose work excited considerable critical attention at the group shows was underplayed in the writings on Impressionism from the 1890s until the 1970s. Born in Paris in 1848, Caillebotte enrolled in Léon Bonnat's studio in 1872, and was admitted to the École des Beaux-Arts in the following year. It was probably through Bonnat that Caillebotte met Edgar Degas, who included his name among those he hoped to recruit for the first independent exhibition. Caillebotte did not show then, but two years later, responding to an invitation from Henri Rouart and Renoir, he submitted eight works, including *The Floor-scrapers* (Pl. 66). Maurius Chaumelin's comments in *La Gazette [des Etrangers]* sum up the sensation caused by the exhibition of this unusual subject, with its extreme perspective, by a hitherto unknown artist:'Who knows Caillebotte? Where does he come from? In what school was he trained? No one has been able to tell me. All I know is that Caillebotte is one of the most original painters to have come forward in some time, and I am not afraid I shall compromise myself by predicting that he will be famous before long.' Paintings of urban workers, like Degas's representations of laundresses, five of which were included at the second exhibition, were regarded not only as vulgar but as politically radical, and the comparison with Courbet was often made, particularly with his *Stone Breakers*.

At the third exhibition in 1877, Caillebotte was represented by six works. They included *Paris Street, A Rainy Day* (Pl. 64), *The Europe Bridge* (Pl. 67) and *Portraits in the Country* (Pl. 65). *Portraits in the Country* was painted in the garden of the Caillebotte family estate at Yerres, and the models were members of his family. The upward tilt of the foreground and the extreme diagonal of the perspective are characteristic of Caillebotte's work, while the lack of relationship between the figures, each represented as intent on her own occupation, is a feature of much of Caillebotte's art, as it was to be of Seurat's.

Paris Street, A Rainy Day is a huge painting. Unlike contemporary images of urban life which represent a 'slice of life' in an apparently informal manner, Caillebotte made the intersection of the Rue de Turin and the Rue de Moscow, near the Gare St Lazare, serve as the backdrop to a formalized and monumental assertion of the 'heroism of modern life'. It is comparable to Seurat's *Sunday Afternoon on the Île de la Grand-Jatte* (Pl. 76) both in its scale and in the gravity with which it represents modernity. Its quality of being absolutely of the minute was noted by Lepelletier in *Le Radical*: 'Two figures in the foreground stand out in harsh light: a gentleman and a lady, modern dress, contemporary physiognomies, sheltered under an umbrella that seems freshly taken from the racks of the Louvre [the department store] and the Bon Marché.' A number of critics thought that the painting's ambitions were not entirely realized, and Georges Rivière was clearly being somewhat defensive when he wrote in *L'Impressionniste*:

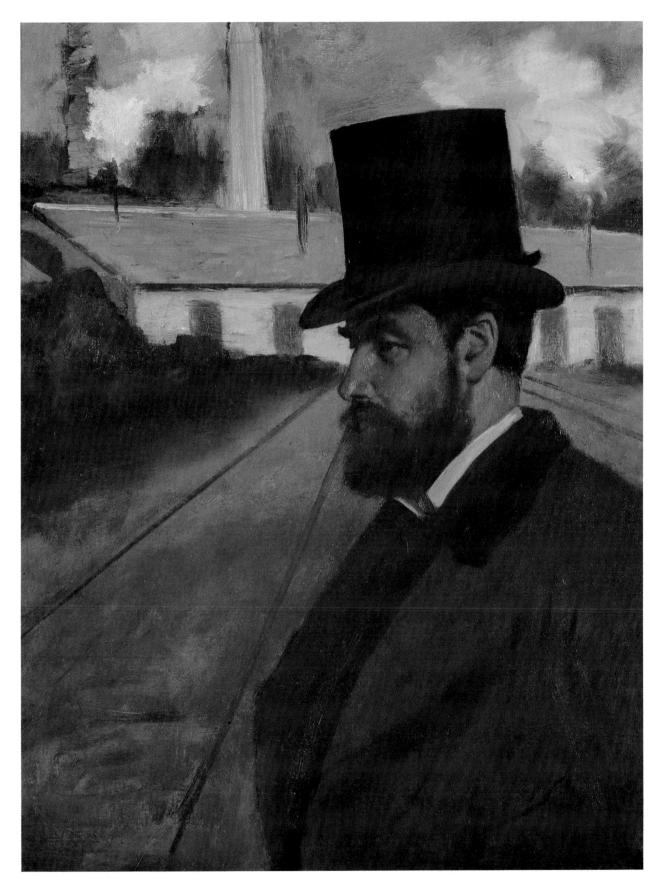

58. Edgar Degas. *Portrait of Henri Rouart*. 1875. Oil on canvas, 65 × 50 cm. Pittsburgh, Penn., Carnegie Museum of Art

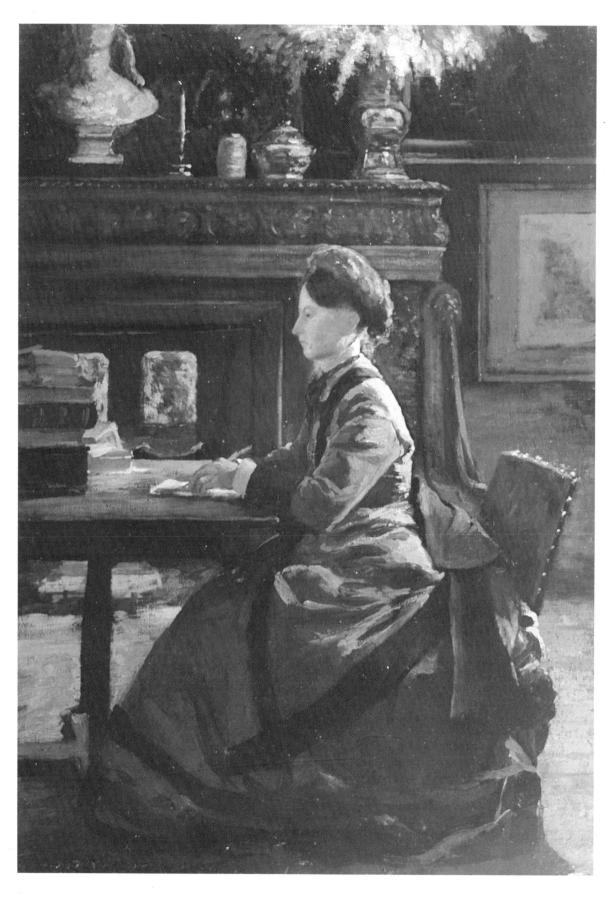

59. Henri Rouart. *Portrait of Madame Rouart. c.*1872. Oil on canvas, 66 × 47 cm. Paris, Collections Galerie Hopkins-Thomas

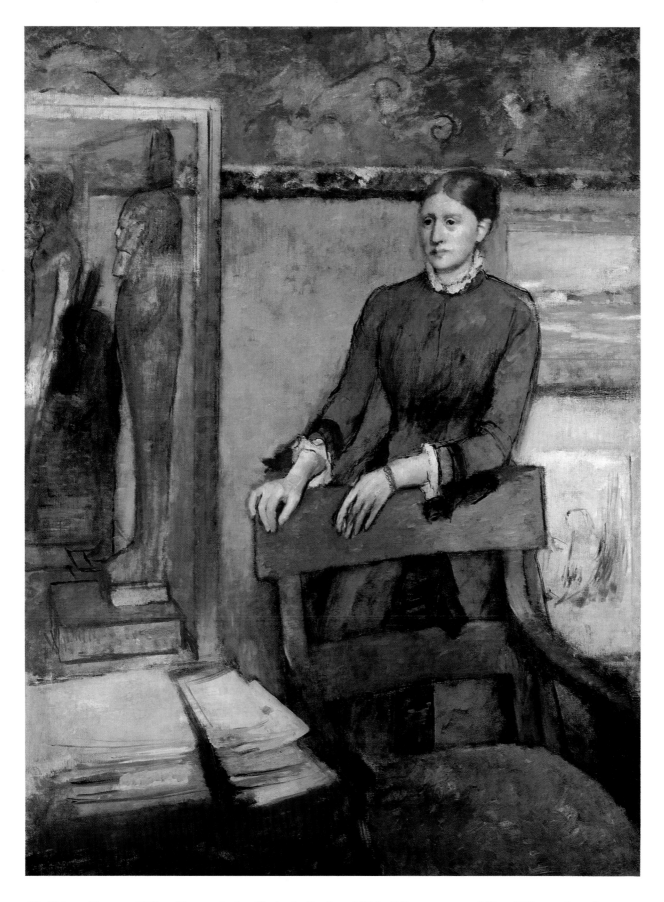

60. Edgar Degas. *Hélène Rouart in her Father's Study. c.*1886. Oil on canvas, 161 × 120 cm. London, National Gallery

61. Berthe Morisot. *Woman and Child in a Garden*. 1884. Oil on canvas, 59 × 72 cm. Edinburgh, National Gallery of Scotland

62. Henri Rouart. *Young Woman Reading. c.*1880. Oil on canvas, 45 × 60 cm. Private collection

'Those who criticized this painting had no idea of how difficult it was and what technique was needed to bring off a canvas of this size.'

The Europe Bridge, also a large painting, is as emphatically modern. It shows the bridge over the cutting of the Gare St-Lazare, in the quarter of Europe, so called because the streets were named after European cities. At the third exhibition seven canvases from Monet's series of paintings of the Gare St-Lazare were on show in the same room as Caillebotte's large canvases. They included a view of the Europe Bridge (Pl. 68), which differs in many ways from Caillebotte's canvas. Caillebotte's use of hard-edged, precisely delineated forms, exaggerated perspective, and his insistence on the contemporaneity of his subject matter places him within the broader category of naturalist painting. The naturalists' concern was with contemporary society and its surroundings, with modernity, and it was beginning to find a place in the Salons. Caillebotte's close friend Jean Béraud (Pl. 72), who was never part of the Impressionist group, was one of its leading exponents. By contrast, Monet emphasizes the materiality of the paint surface and explores a variety of diferent mark-making procedures. Although the architectural forms in his view of the bridge are still relatively clear, he is not concerned with rendering each bolt and railing, as Caillebotte is. Caillebotte's technique remains close to that of his master Léon Bonnat: it is essentially academic. His submissions to the 1877 exhibition assert the possibility for heroic painting in the everyday life of the city.

In 1879, at the fourth exhibition, Caillebotte showed his largest collection of works to date, sixteen oils, including eight portraits (Pl. 71); three decorative panels; and six pastels. Among the oils was *View of Rooftops* (Pl. 69), where the strong perspective effect created by the accentuated diagonal of the rooftops is a similar compositional device to that employed in other, more obviously structured paintings. *Bathers, Banks of the Yerres* (Pl. 73) is a pastel, one of many river scenes painted near the family estate. In addition to his interest in the theme of bathers, Caillebotte, an enthusiastic boatman, often represented various forms of *canotage*, for example *A Man Docking His Boat* (Pl. 74). As both Monet and Degas did, Caillebotte used the exhibition as an opportunity to show the range of his abilities, and several critics noted the profusion of his contribution. Henry Havard wrote as a postscript to his review: '. . . I see that I have left out Caillebotte. This omission is more blameworthy because Caillebotte has not stinted himself at the Exhibition of the Independents; his abundance borders on prolixity. He is everywhere, covering entire walls, climbing easels.'

Of the many themes Caillebotte explored, one of the most unusual is that of *Man Drying Himself* (Pl. 77). Although representations of the nude, both male and female, are a commonplace in Western art, the male nude as a genre subject, rather than cast as a heroic or godlike figure, is rare. Cézanne's male bathers disport themselves in an Arcadian setting, but Caillebotte shows the nude in a domestic interior, bathtub in the corner of the room. The man is shown in a pose equivalent to that used by Degas in his *Bathers* of the same date. Like Degas's female figures (Pl. 78), the man in Caillebotte's painting is reduced to an object, seen from behind and depersonalized, and Degas's comment on his bathroom scenes—'It's as if you looked through a keyhole'—applies equally to Caillebotte's work. Such voyeurism is common in nineteenth-century pornographic images of women, but the combination of the same elements in a representation of a male nude is exceptional. Caillebotte's images of male bathers, either dressed in tight-fitting bathing trunks (Pl. 75) or nude indicates a fascination with the male form; representations of the female nude are rarer in his painted output.

In 1880, at the fifth exhibition, Caillebotte showed fewer works: eight oils and three pastels. Among them was *In a Café* (Pl. 70). Caillebotte uses the device of the mirror to increase the spatial complexity of the painting; he makes play between the compression of space suggested by the main figure's position, apparently almost intruding

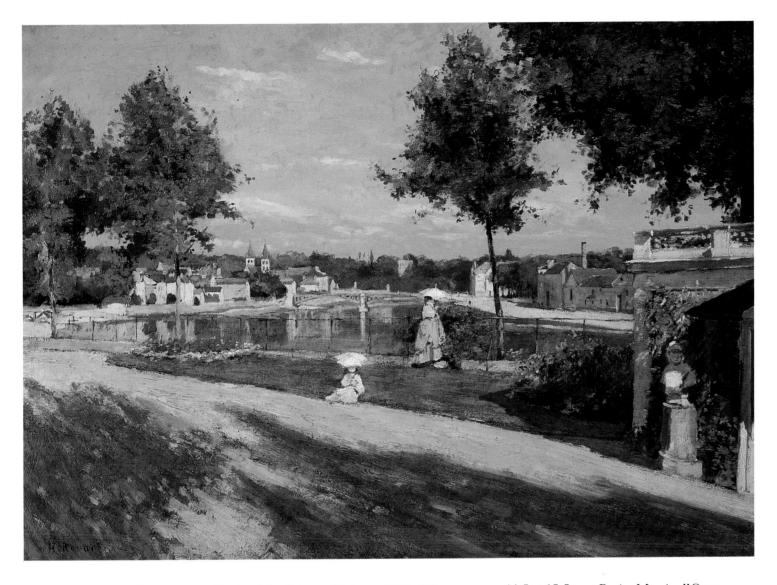

63. Henri Rouart. *Terrace on the Banks of the Seine at Melun. c.*1880. Oil on canvas, 46.5 × 65.5 cm. Paris, Musée d'Orsay

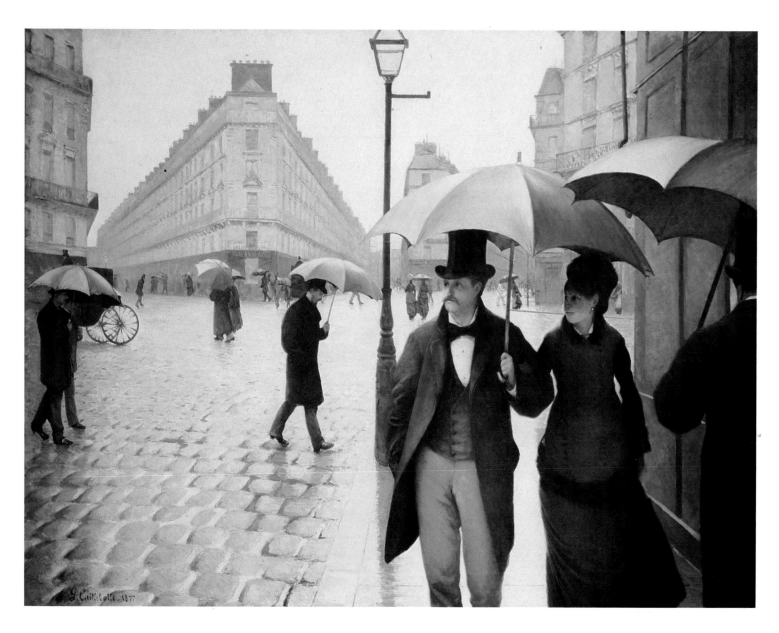

64. Gustave Caillebotte. *Paris Street, A Rainy Day*. 1877. Oil on canvas, 212.2 × 276.2 cm. Chicago, Art Institute of Chicago

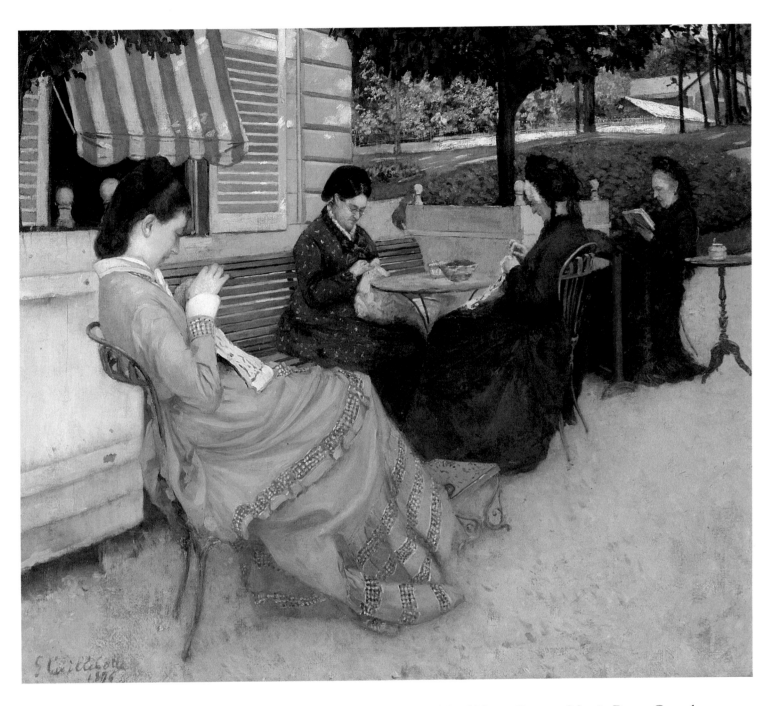

65. Gustave Caillebotte. *Portraits in the Country*. 1876. Oil on canvas, 95 × 111 cm. Bayeux, Musée Baron Gerard

into the spectator's space but confined by the table behind him, and the deep space suggested by the use of the mirrored reflection of the remainder of the café. The theme of café life was one being increasingly explored by naturalist painters, not only Manet and Degas, but also painters such as Béraud, for example in *At the Ambassadeurs* (Pl. 72). Unlike Béraud's painting, in which a young woman engages in dalliance with her companion, Caillebotte includes only men in his café scene. Joris-Karl Huysmans singled out Caillebotte's contribution for lengthy consideration in his review of the exhibition; he considered that Caillebotte had interpreted 'the modern formula' in a manner preferable to that of Manet.

After the difficulties he had had with the organization of the group shows, particularly the seventh show in 1882, Caillebotte withdrew increasingly from the art world of Paris, spending most of his time at Petit-Gennevilliers, across the Seine from Argenteuil. Rumour had it that he gave up painting entirely at this stage of his career, but this was untrue: he continued to paint until his death in 1894, although he concentrated more on views of his own garden and scenes of the Seine at Argenteuil than on his ambitious urban subjects of the 1870s.

When Caillebotte died on 21 February 1894, it was Renoir, who, as an executor of his estate, wrote to Henri Roujon, Director of Fine Arts, revealing that Caillebotte had left a collection of sixty works by Cézanne, Degas, Monet, Pissarro, Sisley, Millet and Manet to the Musée du Luxembourg, which housed contemporary art, or to the Louvre. Caillebotte had purchased works that seemed particularly unsaleable, that is, paintings which departed most markedly from the acceptable norms of either Salon paintings or of dealer paintings. In some cases these were large works, such as Renoir's *Moulin de la Galette*, in other cases paintings, particularly by Cézanne, which a dealer such as Durand-Ruel would not have been able to sell. Among the collection were many paintings exhibited at the third show in 1877. Even seventeen years later, the bequest caused considerable embarrassment to the State, which refused to accept it in its entirety.

It was because of the vital role he played as a collector in the 1870s that Caillebotte so quickly established himself as a prominent figure in the Impressionist group. Unlike some supporters, such as Eugène Murer, Caillebotte was distinguished by the high prices he paid, often more than he was asked. By 1882, his support as a patron was no longer as necessary as it had been in the mid-1870s. Both Monet and Renoir were reasonably established, and even other members of the group such as Pissarro had access to a wider range of potential buyers than had been the case seven or eight years earlier.

Caillebotte was initially welcomed into the group as a collector, rather than as a colleague, and this was true too of Paul Gauguin. Gauguin had begun collecting paintings in the mid-1870s, amassing works by Monet, Pissarro, Renoir, Sisley, Guillaumin and Cézanne. At this time he was a stockbroker and a Sunday painter, who had had a landscape accepted at the Salon in 1876. After meeting Pissarro in 1877, he painted with him in Pontoise and the Osny region in 1879 and on several subsequent occasions during the early 1880s, observing Pissarro's working method and behaving very much as a pupil, not an equal. He first participated in the group exhibition of 1879, when he showed a marble bust of his son Emil, and in 1880 his submission consisted of seven paintings and a bust of his wife Mette. The critics were in the main dismissive of his work, regarding it as clumsy and inconsequential, but it was Gauguin's position as a serious collector that was of more interest to his artist associates. Until he gave up his business career in 1883 to devote himself to painting, it was as a collector that he found a place in the group shows.

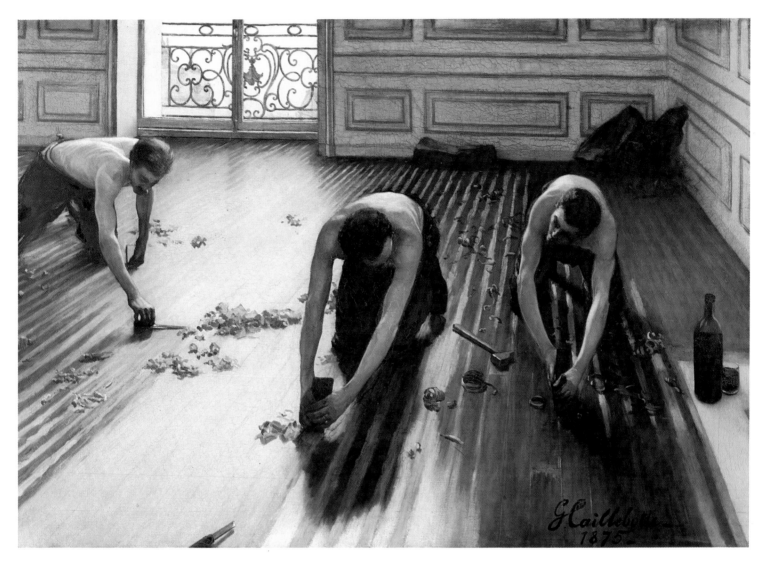

66. Gustave Caillebotte. *The Floor-scrapers*. 1875. Oil on canvas, 102 × 146 cm. Paris, Musée d'Orsay

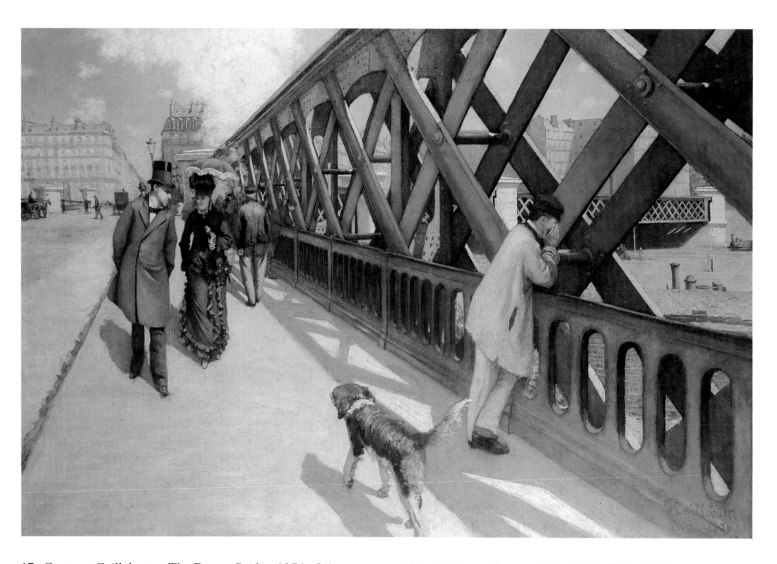

67. Gustave Caillebotte. *The Europe Bridge*. 1876. Oil on canvas, 125 × 180 cm. Geneva, Musée du Petit-Palais

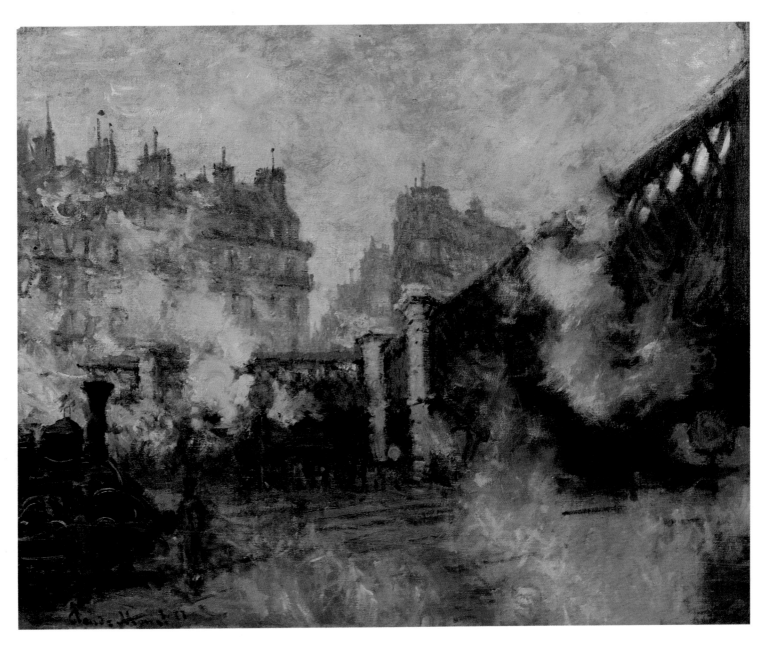

68. Claude Monet. *The Europe Bridge*. 1877. Oil on canvas, 64 × 81 cm. Paris, Musée Marmottan

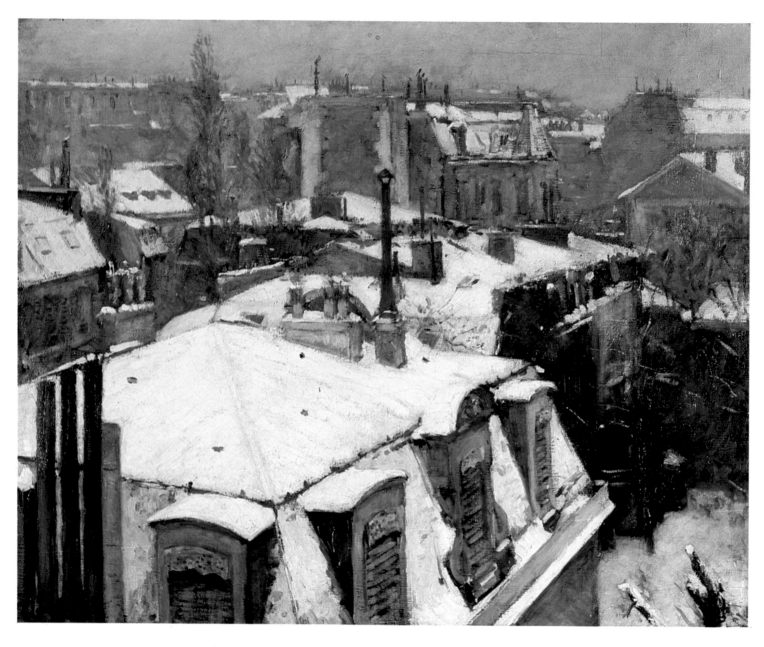

69. Gustave Caillebotte. *View of Rooftops (Snow Effect)*. *c*.1878. Oil on canvas, 64 × 82 cm. Paris, Musée d'Orsay

70. Gustave Caillebotte. *In a Café*. 1880. Oil on canvas, 153 × 114 cm. Rouen, Musée des Beaux-Arts

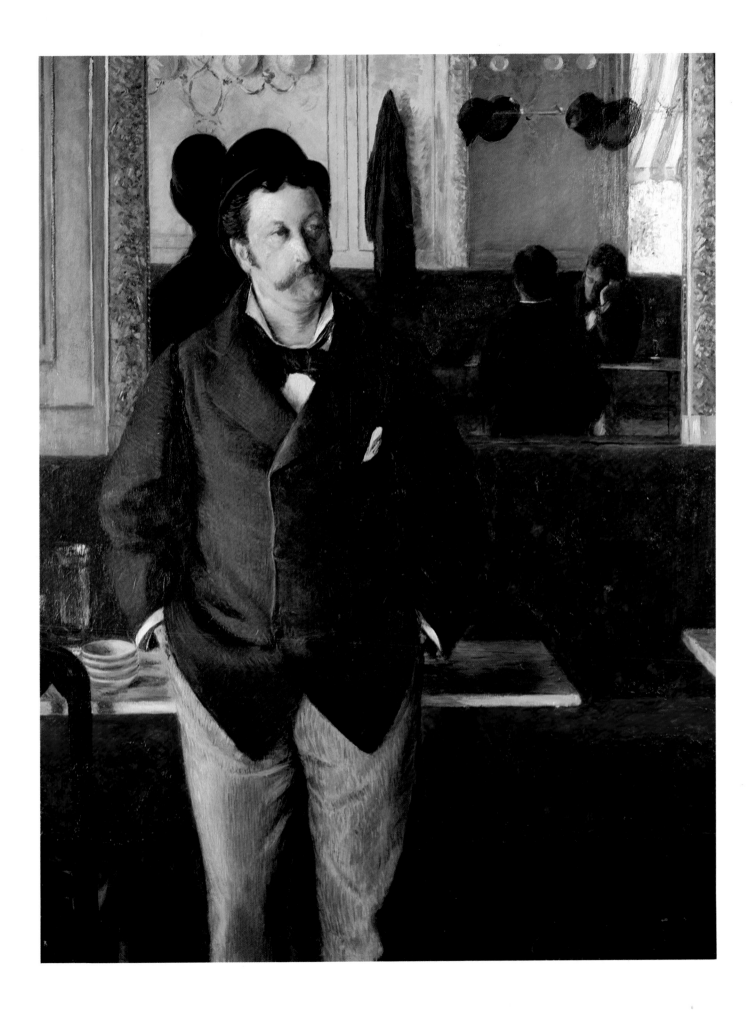

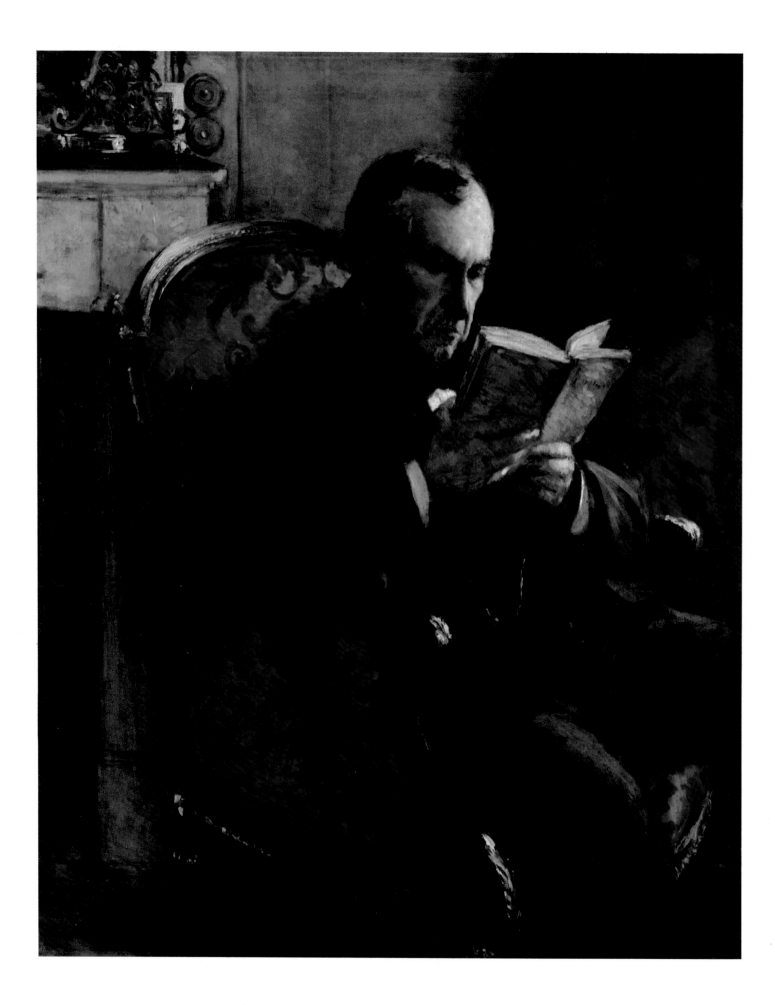

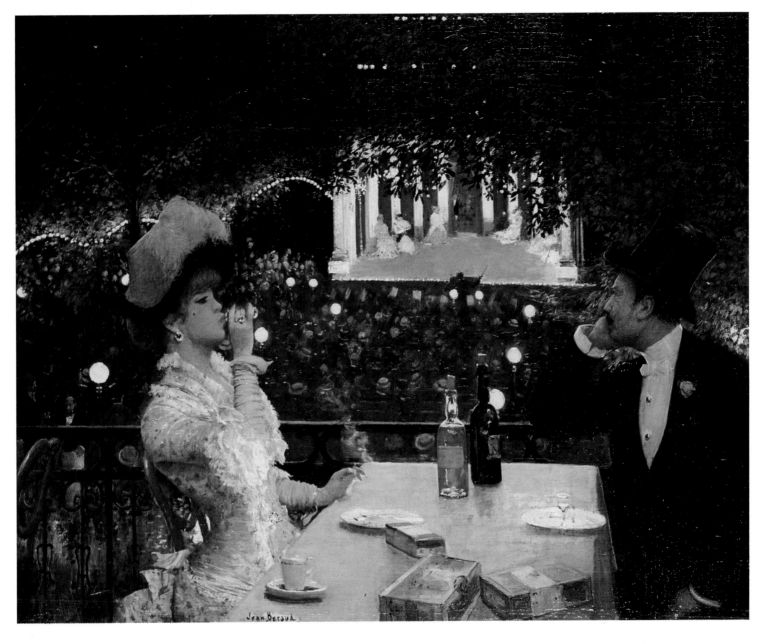

72. Jean Béraud. *At the Ambassadeurs. c.*1880. Oil on canvas, 60 × 75 cm. Paris, Musée des Arts Decoratifs

71. Gustave Caillebotte. *Portrait of Eugène Daufresne.* 1878. Oil on canvas, 100 × 81 cm. Josefowitz Collection

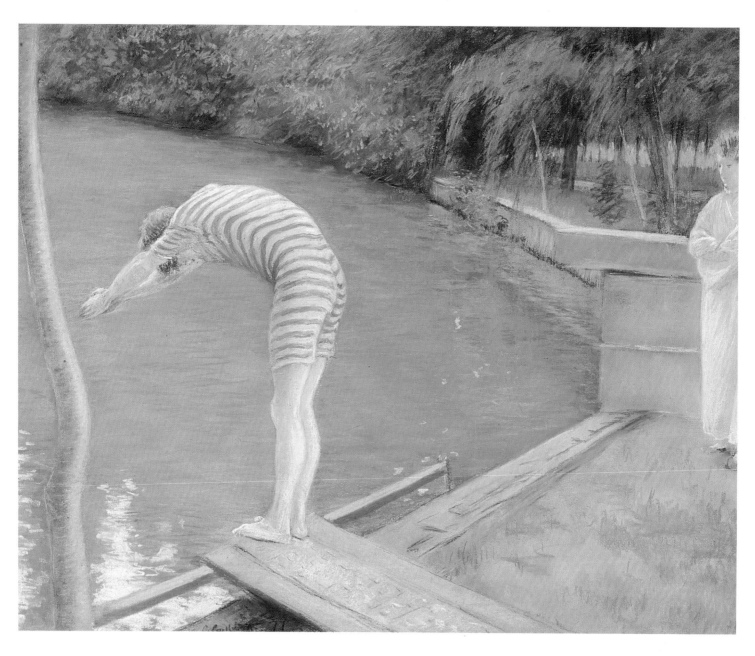

73. Gustave Caillebotte. *Bathers, Banks of the Yerres*. 1877. Pastel on canvas, 75 × 95 cm. Agen, Musée d'Agen

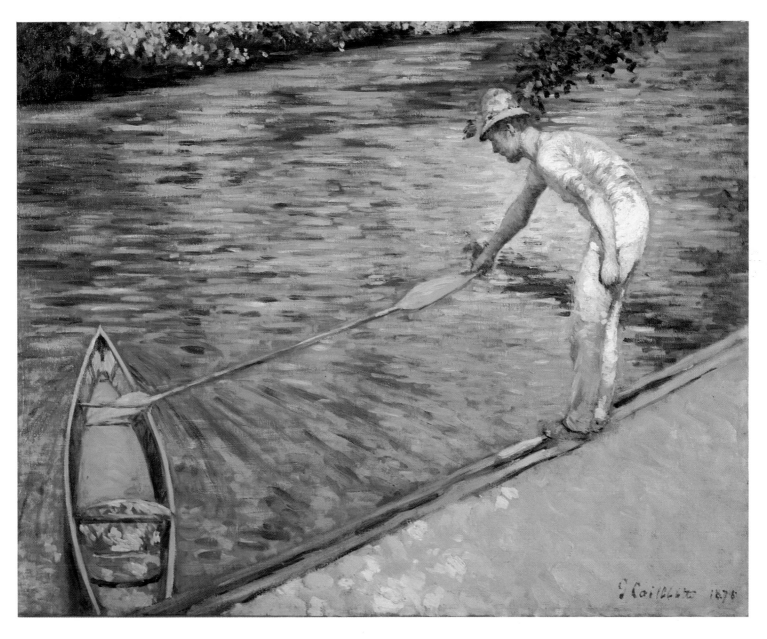

74. Gustave Caillebotte. *A Man Docking his Boat*. 1878. Oil on canvas, 73.6 × 92.7 cm. Richmond, Va., Virginia Museum of Fine Arts

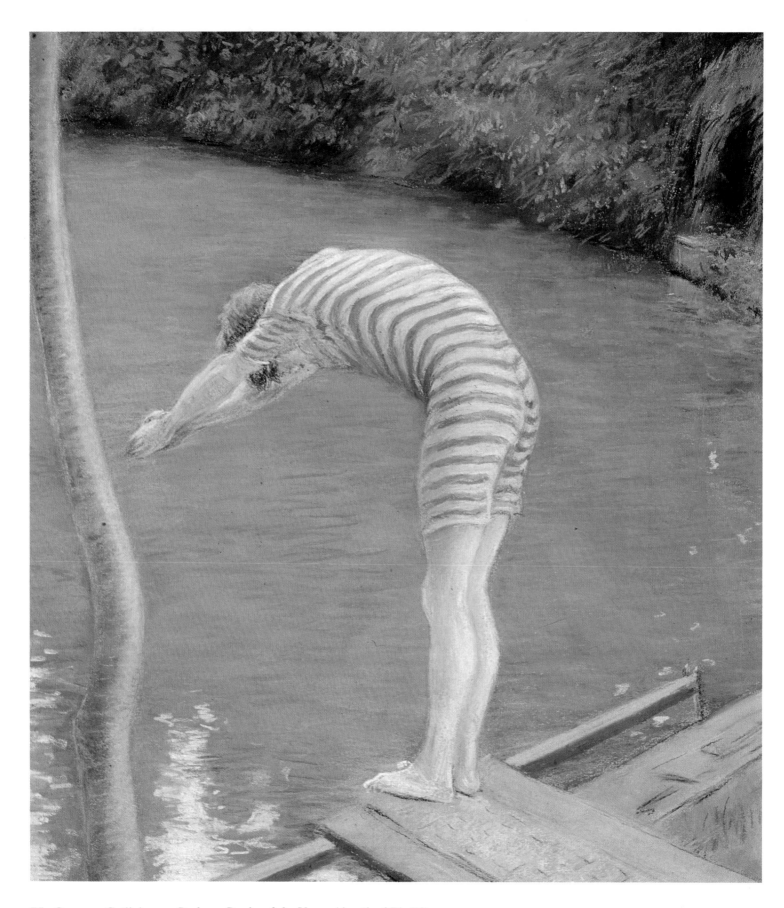

75. Gustave Caillebotte. *Bathers, Banks of the Yerres* (detail of Pl. 73)

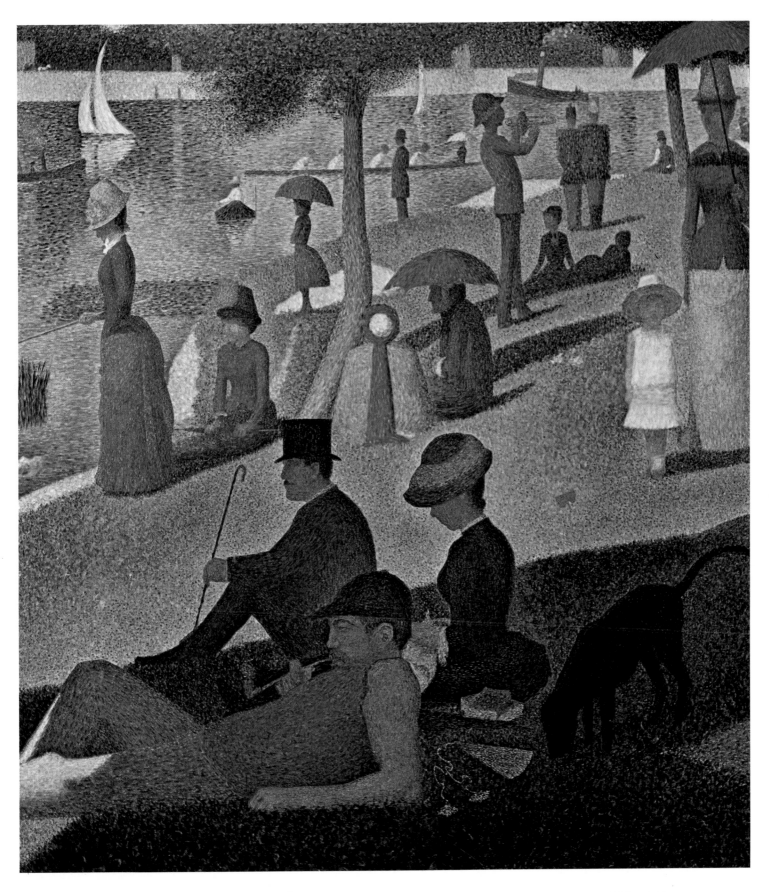

76. Georges Seurat. *Sunday Afternoon on the Île de la Grande-Jatte* (detail). *c.*1884–6. Oil on canvas, 225 × 340 cm.
Chicago, Art Institute of Chicago

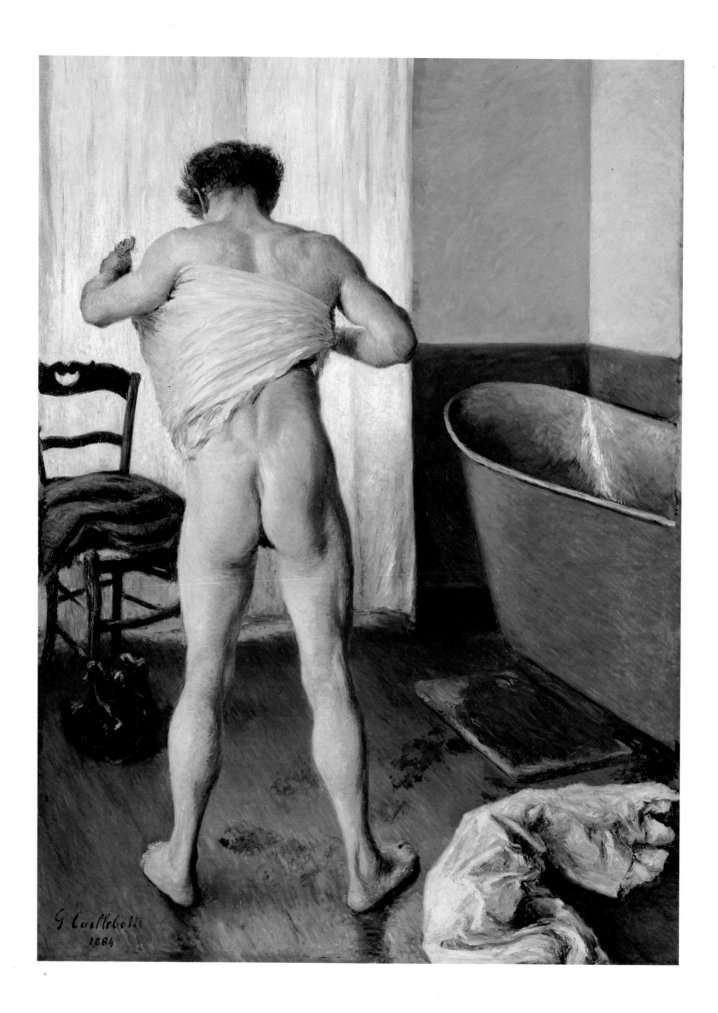

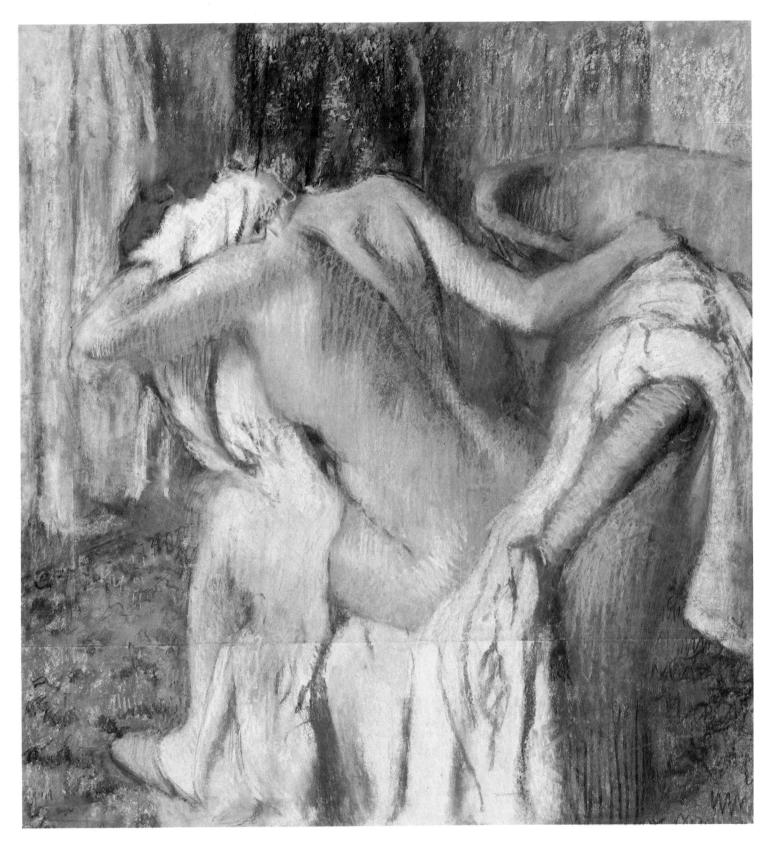

78. Edgar Degas. *After the Bath: Woman Drying Herself.* *c.*1883–90. Pastel on paper, 104 × 98.5 cm.
London, National Gallery

77. Gustave Caillebotte. *Man Drying Himself.* 1884. Oil on canvas, 166 × 125 cm. Josefowitz Collection

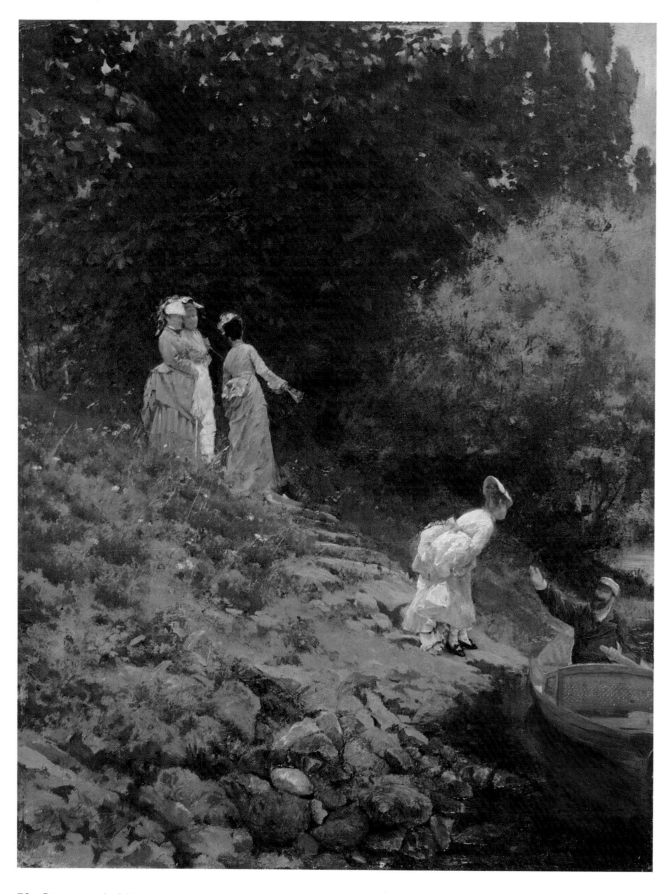

79. Giuseppe de Nittis. *Landscape on the Bank of a River (La Grenouillère). c.*1873. Oil on canvas, 35 × 28 cm. Private collection

5 *The Realists*

Degas identified his enterprise as realism. When unsuccessfully attempting to recruit James Tissot for the first exhibition, he wrote: 'The realist movement no longer needs to fight with others. It is, it *exists*, it has to *show itself separately*. There has to *be a realist Salon*.' By 'realism' he would have meant something similar to the definition offered by Pierre-Joseph Proudhon in 1865 as 'The Aim of Art': 'To paint men in the sincerity of their natures and their habits, in their work, in the accomplishment of their civic and domestic functions, with their present-day appearance, above all without pose . . .'.

Of the artists at the first exhibition who were close to Degas, only Giuseppe de Nittis could be called a realist. This was because, to Degas's disappointment, Manet, Tissot and Fantin-Latour all chose not to show; Rouart was producing Corotesque work which could not be described as realist, nor could the work of Ludovic-Napoléon Lepic. De Nittis's submission of five works consisted of three Italian landscapes, two of a subject which had a wide appeal as a tourist memento—views of Mount Vesuvius; one French landscape of the area around Blois; and a work entitled *Studies of a Woman.* He had already shown his interest in modernity in works such as *The Passing Train* (Pl. 81), in which the diagonal movement of the train across the field suggests the impact of the arrival of the railways, and the changes they brought to remote rural communities. The angle of vision and the emphasis on the diagonal indicates that de Nittis was aware of such devices as the hallmark of the 'modern' painter.

Even before coming to France, de Nittis was interested in representations of contemporary life. While he worked in Naples, he was a member of the group called the School of Resina who tried to integrate the ideas of their Tuscan contemporaries the Macchiaioli with their own views on contemporary naturalism. The Macchiaioli were so named because of the extensive use they made of '*macchia*' (or, in French, the '*tache*'), the patch or touch which was seen in France in the 1860s to be a distinguishing feature of anti-academic painting. The Macchiaioli had close links with French art, and Degas in particular was an enthusiastic supporter of their work, recognizing its affinities to his own ideas. In de Nittis he found a painter whose work shared many of the qualities of the Macchiaioli and who, furthermore, had social connections which might secure patronage for the putative 'realist Salon'. This made him an eminently suitable recruit, but after his single showing at the independent exhibition, de Nittis chose not to participate again. He continued to explore themes similar to those found in the work of Manet, Renoir and Monet. In *Landscape on the Bank of a River (La Grenouillère)* (Pl. 79), he depicted the bathing spot on the Seine at which Monet and Renoir had worked in 1869, but his work is differentiated from theirs by its narrative element. La Grenouillère was well known as a favourite place for Parisian bourgeois men to meet women of the demi-monde, and the young women on the bank would immediately have been recognized by contemporary audiences as demi-mondaines. The painting's mildly salacious character would have ensured its saleability. *On the Banks of the Seine* (Pl. 6) is a small

canvas of one of the many areas on the Seine which were favoured places for leisure and favoured, too, by the demi-monde. Such landscapes were commissioned by the dealer Goupil from de Nittis's countrymen Telemaco Signorini and Giovanni Boldini to meet a growing demand from urban dwellers for whom such locales, accessible to the city and thoroughly tamed, represented an ideal of nature: this canvas, too, may have been sold by Goupil. In *On a Bench on the Champs Elysées* (Pl. 80) de Nittis is at his most urbane, representing a scene of everyday life instantly familiar to his audience, while *La Place des Pyramides* (Pl. 82) of 1875 is aggressively modern, with its forceful reminder in the scaffolding and the burned-out Tuileries Palace in the background of the damage Paris had suffered during the Commune.

After de Nittis's participation in the 1874 exhibition, he returned to the Salon. In 1880 he had an extremely successful exhibition at the offices of *La Vie Moderne*, the periodical run by the publisher Georges Charpentier. He died in 1884.

Federico Zandomeneghi, who showed at the fourth, fifth, sixth and eighth exhibitions, was also Italian. Born in Venice in 1841 into a family of sculptors, he studied at the Accademia di Belli Arti in Venice, but left in 1859 to avoid conscription and went to Pavia. In 1860 he was one of Garibaldi's volunteers in the expedition of the Thousand to liberate Sicily. He was unable to return to Venice immediately since he was wanted for desertion, and went instead to Florence. He was a member of the group who gathered at the Caffè Michelangiolo, and was close to several of the Macchiaioli, particularly to the critic Diego Martelli. Telemaco Signorini, a Macchiaiolo working in Paris, and de Nittis kept Zandomeneghi informed about the Paris art world, and in 1874 he left Italy for Paris where he lived until his death in 1917.

He frequented the Café de la Nouvelle-Athènes, where he soon became known as one of the 'disciples of Degas', but initially he had to struggle to attain any recognition. In 1878 he met Durand-Ruel, and his situation improved. In the same year his friend Diego Martelli came to Paris to report on the Universal Exhibition for several Italian newspapers. Zandomeneghi and Marcellin Desboutin took him to the café, and by the end of the year Martelli commented wryly in a letter that he was 'running the risk of becoming a friend of Degas'. In 1879 both Zandomeneghi and Degas painted Martelli's portrait (Pls. 83, 84), and both portraits were shown at the fourth exhibition in that year. Zandomeneghi shows the writer seated at a desk wearing a skullcap and a red and grey gown, in front of a fire. The figure fills the canvas, and the attitude is relaxed, one hand in a pocket, one hand stroking the beard. Degas's portrait has a high viewpoint, looking down on the rotund figure, who occupies only the left half of the canvas and is perched on a stool. While both paintings are affectionate records of a friend, Zandomeneghi's has a precise, almost academic finish, while that of Degas, completed in haste, is boldly and freely worked.

In *Fishing on the Seine* (Pl. 39), Zandomeneghi reveals how he had assimilated the vital ingredients of the 'modern formula'. A scene of leisure, it is distinctly urban rather than rural, with the fashionably dressed young woman carefully seated on a stool, shielding herself from the sun with a parasol, and the oddness of the viewpoint, with only the top hat of the man fishing visible, is directly counter to academic tenets. In the background the trail of smoke from a passing train serves as a reminder of industrialization, key element in the concept of modernity.

Place d'Anvers (Pls. 85, 87) is a more elaborate evocation of *la vie moderne*. The Place d'Anvers is a small square, flanked on one side by the Lycée Jacques Decour and facing the Boulevard Rochechouart. It is a place lacking in charm, and intensely urban, with its formal flowerbeds and regimented rows of trees. Shown at the sixth exhibition, Zandomeneghi's painting includes a collection of urban types which invites comparison with Seurat's *Sunday Afternoon on the Île de la Grande-Jatte* (Pl. 76). While the various figures in Seurat's huge painting are at leisure, the

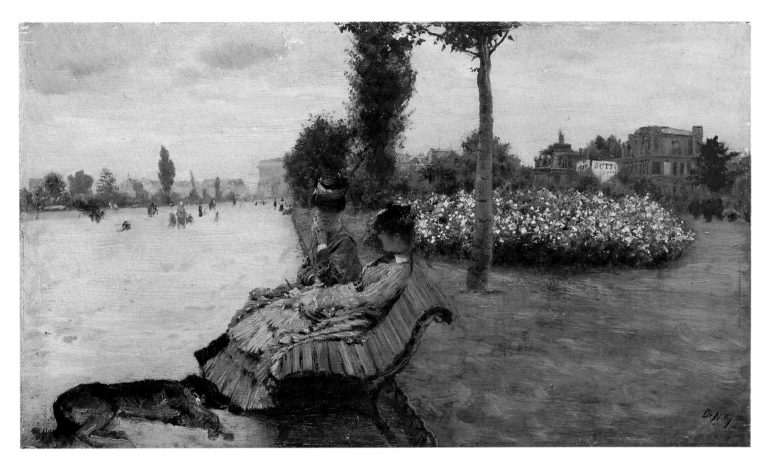

80. Giuseppe de Nittis. *On a Bench on the Champs Elysées. c.*1874. Oil on canvas, 18 × 31 cm. Montecatini, Italy, Collection of Pietro Dini

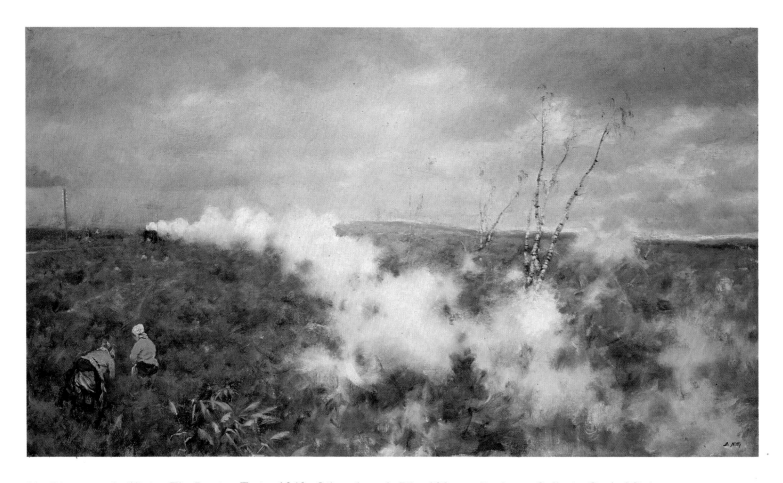

81. Giuseppe de Nittis. *The Passing Train.* 1869. Oil on board, 75 × 130 cm. Barletta, Galleria G. de Nittis

82. Giuseppe de Nittis. *The Place des Pyramides, Paris.* 1875. Oil on canvas, 92 × 74 cm. Paris, Musée d'Orsay

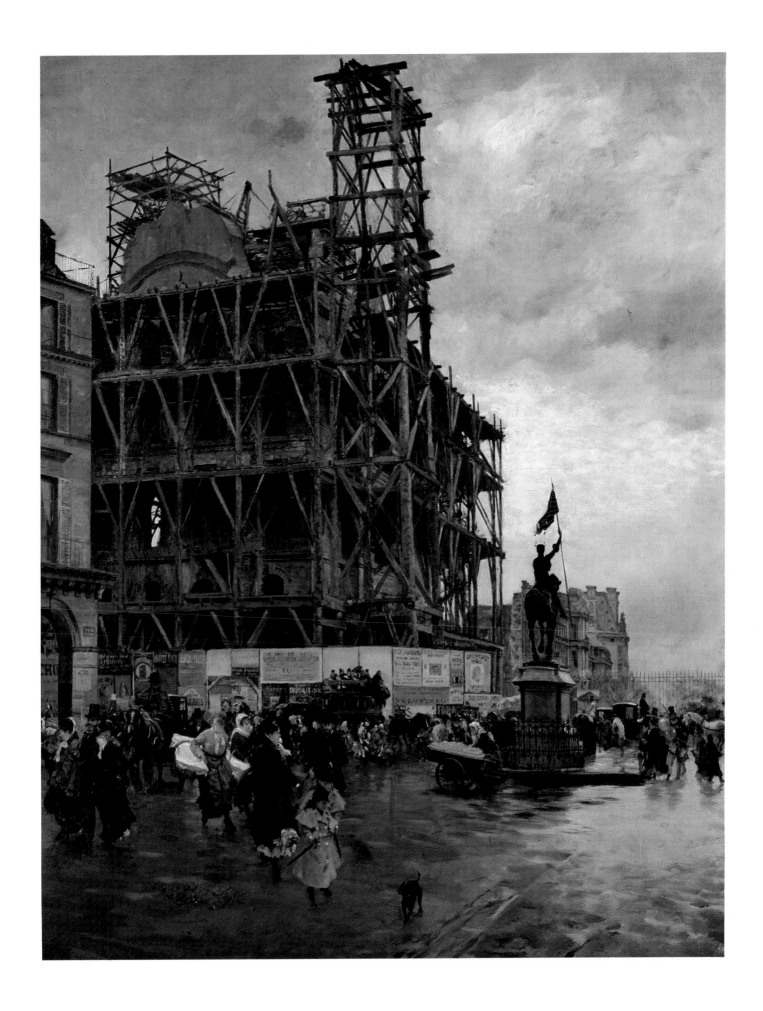

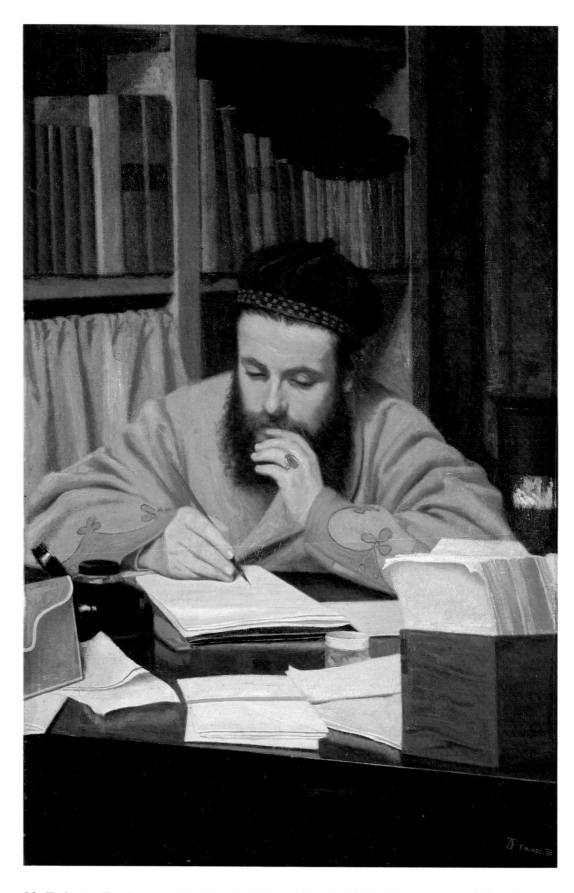

83. Federico Zandomeneghi. *Portrait of Diego Martelli*. 1879. Oil on canvas, 100 × 70 cm.
Florence, Galleria d'Arte Moderna

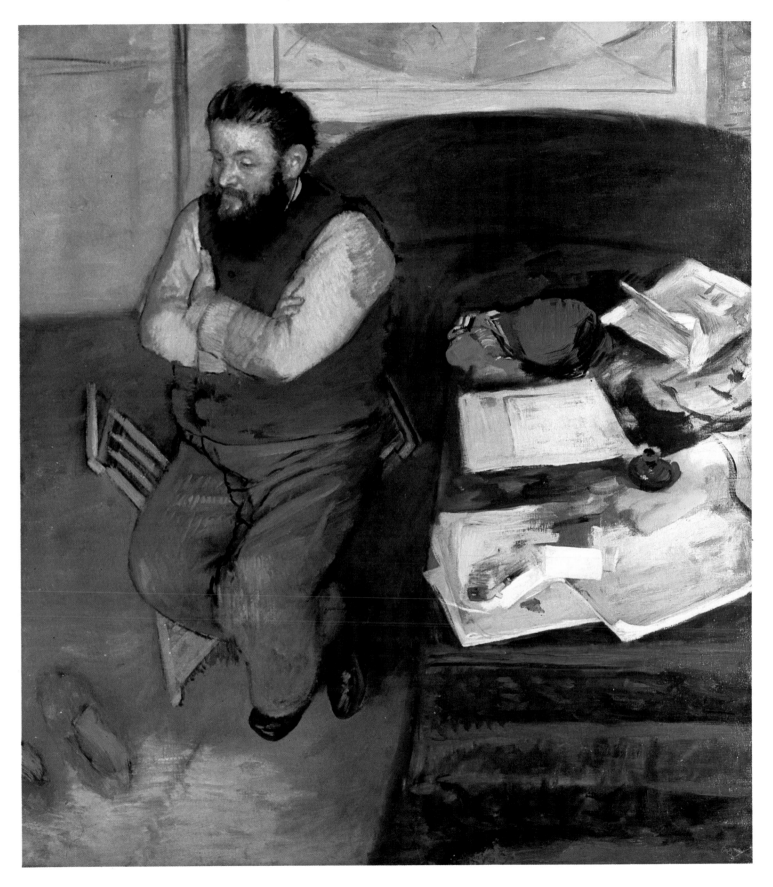

84. Edgar Degas. *Portrait of Diego Martelli*. 1879. Oil on canvas, 107.2 × 100 cm. Edinburgh, National Gallery of Scotland

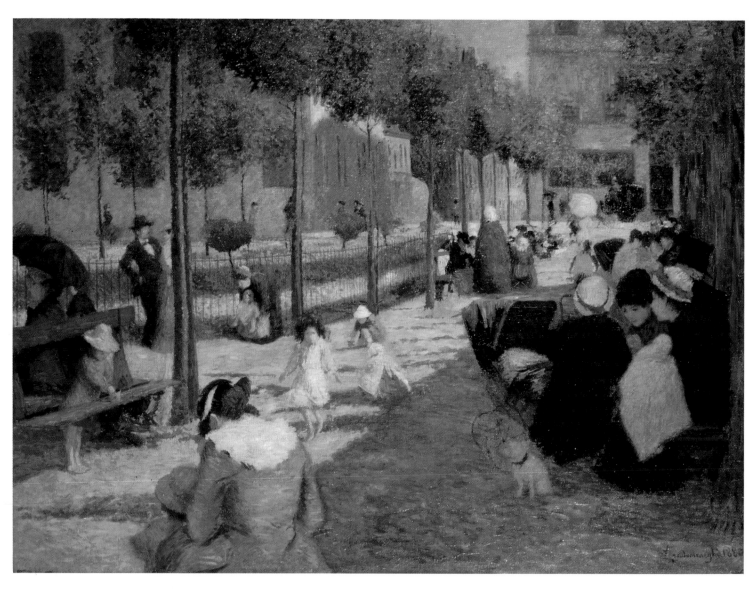

85. Federico Zandomeneghi. *Place d'Anvers, Paris*. 1880. Oil on canvas, 100 × 135 cm. Piacenza, Galleria d'Arte
Moderna Ricci Oddi

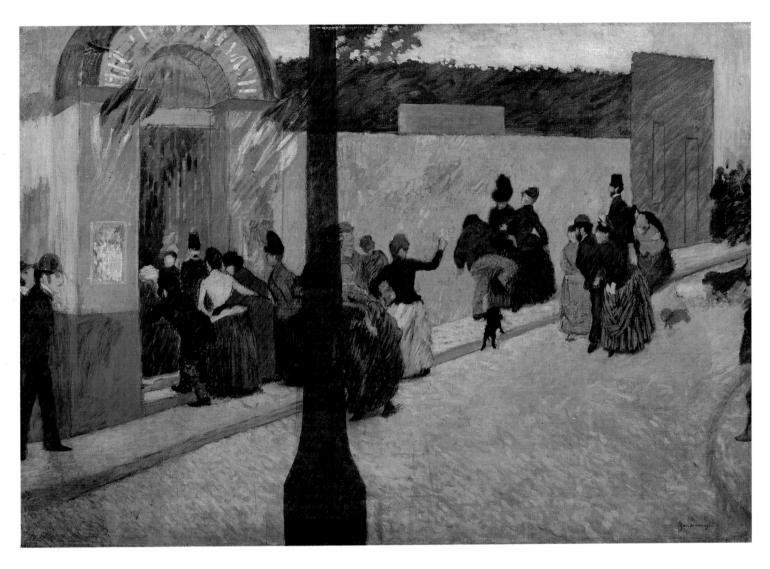

86. Federico Zandomeneghi. *The Moulin de la Galette. c.*1879. Oil on canvas, 80 × 120 cm. Milan, Collection of
Enrico Piceni

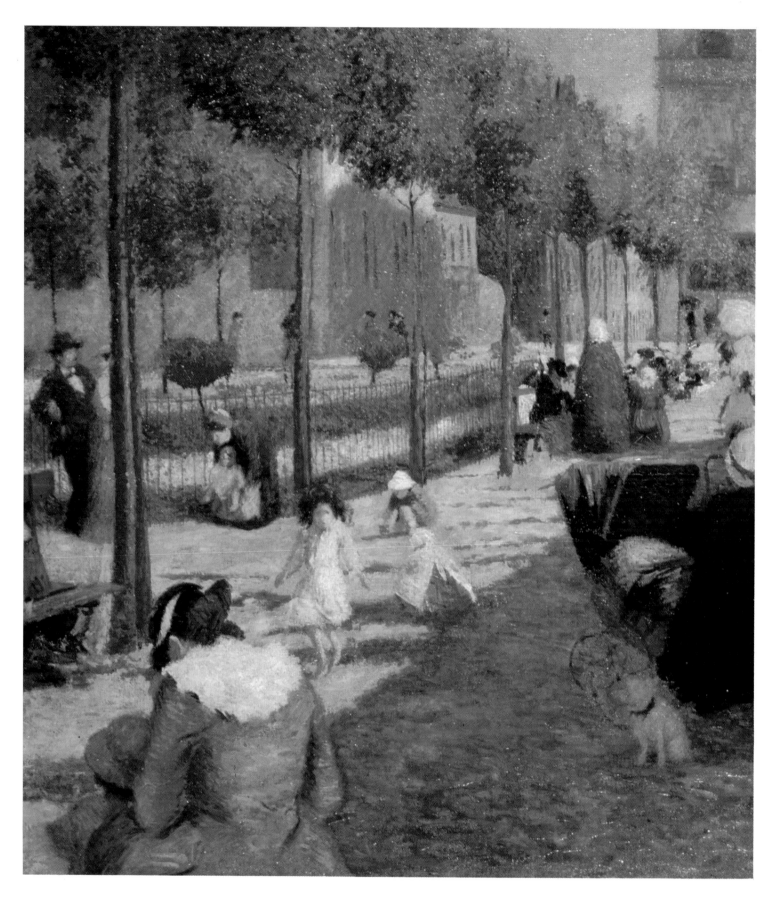

87. Federico Zandomeneghi. *Place d'Anvers, Paris* (detail of Pl. 85)

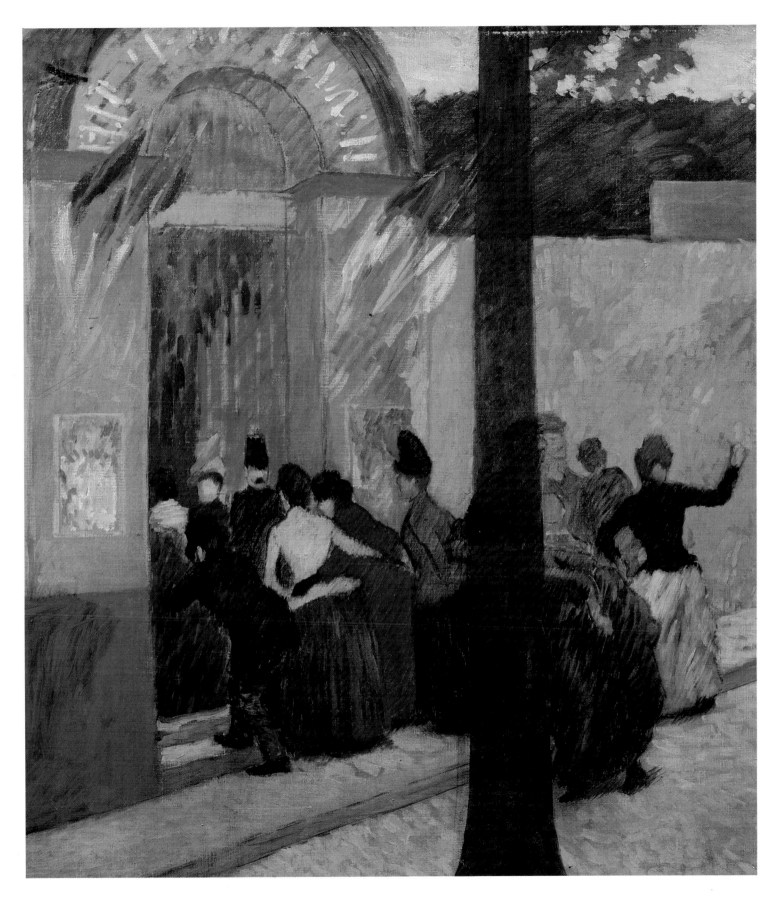

88. Federico Zandomeneghi. *The Moulin de la Galette* (detail of Pl. 86)

women in Zandomeneghi's painting are at work. Almost all of them are nursemaids with their charges, the *nourrices* or wet nurses distinctive with their beribboned bonnets. The standing figure on the left, partly obscured by a tree, is clearly a prostitute soliciting a client. Close to this couple, a wet nurse bends over holding her urinating small charge, while nearby children play in the dust. The women in the background, depicted either alone or in pairs, may also be prostitutes. Zandomeneghi employed a technique more closely related to that of contemporary work by Pissarro than by Degas in this work: the major colour areas are complementary to each other, and within each such area, small brushstrokes of its complementary are introduced to produce an overall harmony while retaining the contrast effect.

Dating from the same period is *The Moulin de la Galette* (Pl. 86), which depicts an excited group, largely female, arriving at the open-air dance hall in Montmartre. The emphatic diagonal of the pavement, the tilted perspective, and the cut-off lamp standard in the foreground, in the manner of a Japanese print, indicate that Zandomeneghi had studied Parisian naturalism carefully, while the caricatural element of the work makes evident his familiarity with the mass of graphic material devoted to themes of café and cabaret life. Toulouse-Lautrec, who was a close friend of Zandomeneghi in the 1880s, is known to have admired his work, and a canvas such as this is close to Toulouse-Lautrec's own later paintings in both theme and intention.

During the organization of the 1880 and 1881 group exhibitions, the painter whose work aroused the most opposition from the other artists involved was Jean-François Raffaëlli. Born in 1850, Raffaëlli first trained as a bookkeeper. He began copying in the Louvre in the late 1860s, and in 1870 had a painting, *At the Edge of the Forest*, accepted at the Salon. At that time, he was working as a singer, with engagements at the Théâtre Lyrique de l'Athenée. During the Franco-Prussian War he served in the army, and after the war he decided to devote himself to studying painting. He entered Gérôme's studio in October 1871, but left after only three months. At the 1872 Salon he submitted two paintings, two drawings, and two sculptures, all of which were refused. In 1873 he had a painting, *Attack under the Trees*, accepted, and sold it for 500 francs, and thereafter he showed regularly at the Salon. Following a visit to Algeria in 1876, he produced exotic works such as *Charming Negress* as well as historical costume pieces, such as *On an Excursion*, set in the period of Louis XIII.

A visit to Plougasnou in Brittany, on the Channel coast near Roscoff, in 1876 changed the direction of his painting. It was there that he painted *The Family of Jean-le-Boiteux, Peasants from Plougasnou-Finistère* (Pl. 90), a large work originally including five figures, one of which Raffaëlli later deleted. The strict profile view of the woman knitting a sock, set against the background wall, and the absolute frontality of the older woman, gnarled hands resting on her lap, indicate that Raffaëlli wished to portray them not only as individual members of a particular family, but as representatives of a group which was accustomed to hard work and physical toil, far removed from the city. As with the vast majority of such representations of peasant life, the intended audience was an urban one, the Parisian Salon goers.

Brittany had been a favourite haunt of painters for many years. In the same year as Raffaëlli produced his painting, Odilon Redon, writing at Quimper on the Atlantic coast, called Brittany 'a sorrowful land weighed down by sombre colours'. Despite rapid changes, both in communications and in agricultural practices, which meant that by the end of the century Brittany was one of the most productive and profitable regions of France, the myth continued that it was a place of 'rustic and *superstitious* simplicity'—as Gauguin described it to van Gogh in 1888. In 1880 Henry Blackburn wrote in *Breton Folk*: 'Nowhere in France are there finer peasantry; nowhere do we see more dignity of aspect in field labour, more nobility of feature amongst men and women; nowhere such primitive habitations and, it must be added, such dirt.' In 1876, to a Parisian such as Raffaëlli, Brittany would have appeared a primitive, strange

89. Jean-François Raffaëlli. *Ragpicker Lighting his Pipe. c.*1879. Oil on canvas, 77 × 59 cm. Nantes, Musée des Beaux-Arts

90. Jean-François Raffaëlli. *The Family of Jean-le-Boiteux, Peasants from Plougasnou — Finistère*. 1876.
Oil on canvas, 188 × 152 cm. Le Quesnoy, Hôtel de Ville

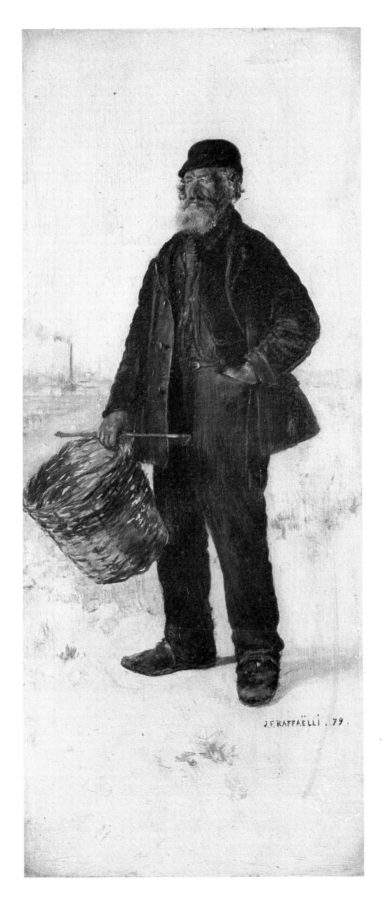

91. Jean-François Raffaëlli. *The Ragpicker.* 1879. Oil on panel, 21.2 × 9 cm. Reims, Musée Saint-Denis

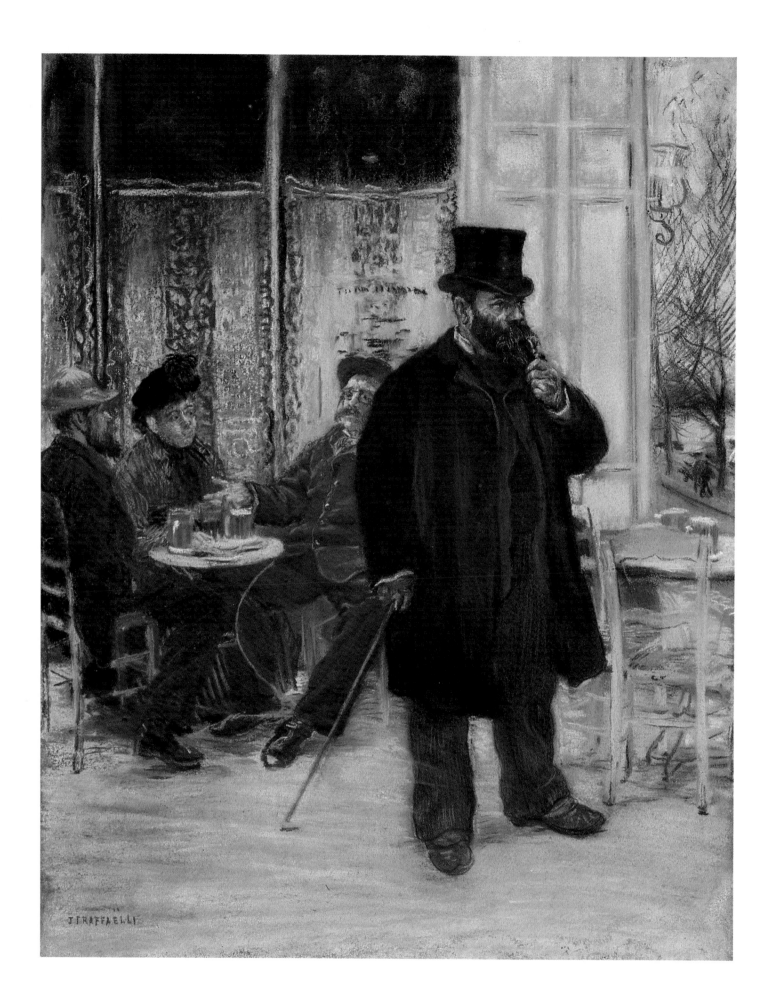

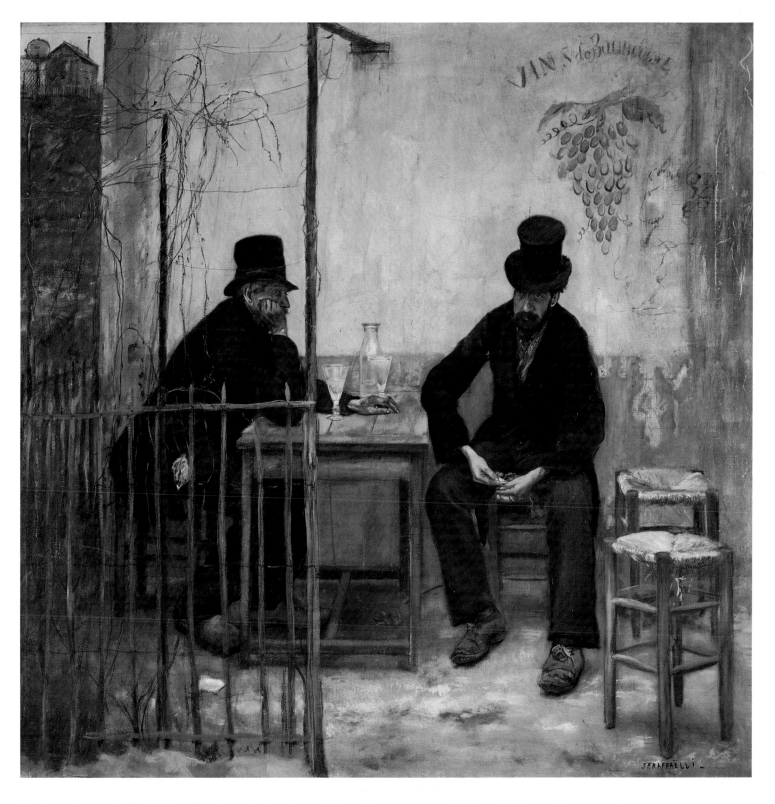

93. Jean-François Raffaëlli. *The Absinthe Drinkers*. 1881. Oil on canvas, 107.7 × 107.7 cm. Private collection

92. Jean-François Raffaëlli. *Bohemians at the Café. c.*1885. Pastel on canvas, 55.5 × 44 cm. Bordeaux, Musée et Galerie des Beaux-Arts

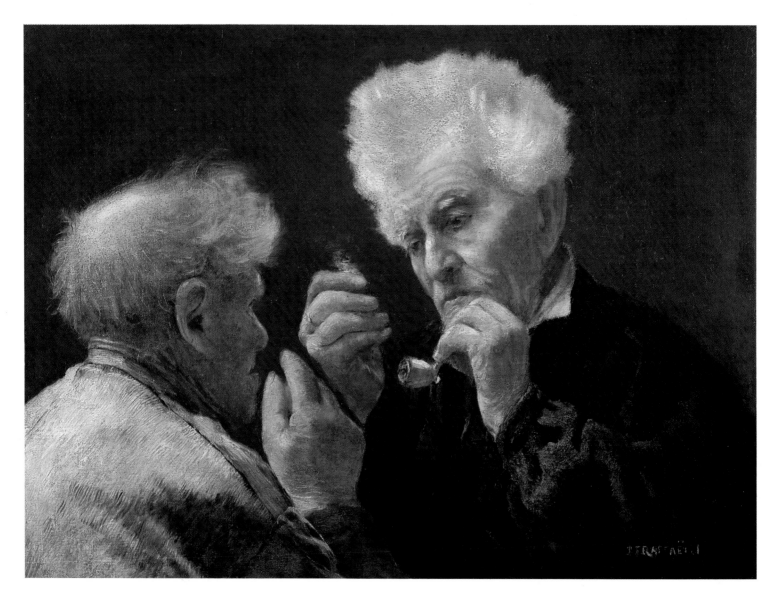

94. Jean-François Raffaëlli. *Mayor and Municipal Councillor. c.*1879. Oil on canvas, 53.5 × 73 cm.
New York, Private collection

95. Jean-François Raffaëlli. *Mayor and Municipal Councillor* (detail of Pl. 94)

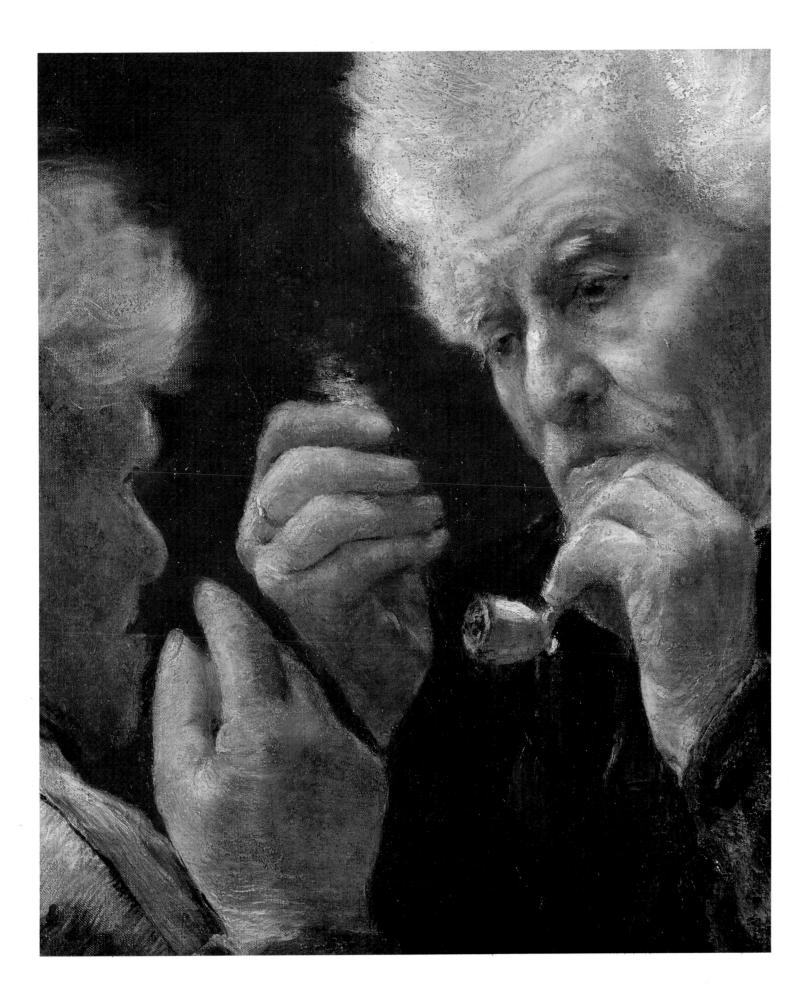

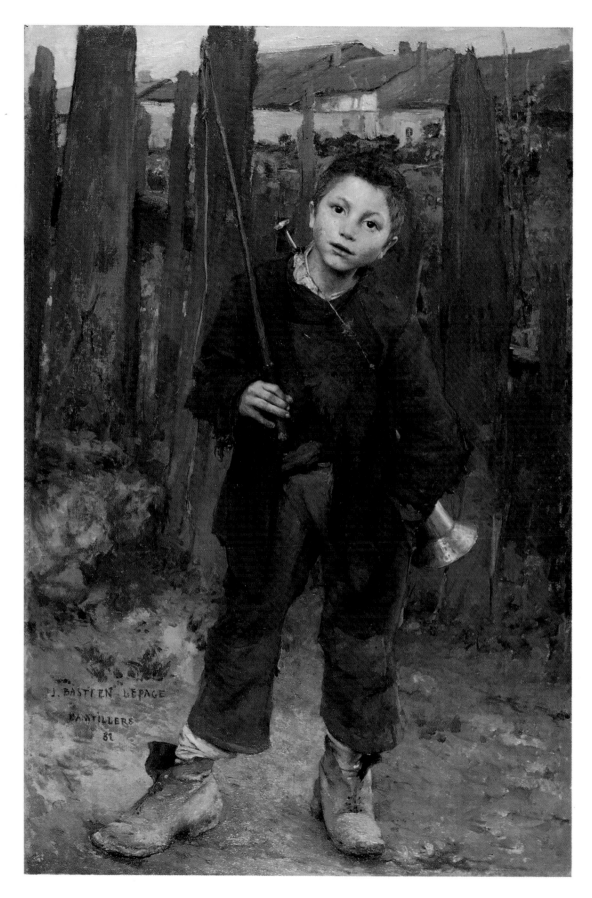

96. Jules Bastien-Lepage. *Nothing Doing.* 1882. Oil on canvas, 132.1 × 88.3 cm. Edinburgh, National Gallery of Scotland

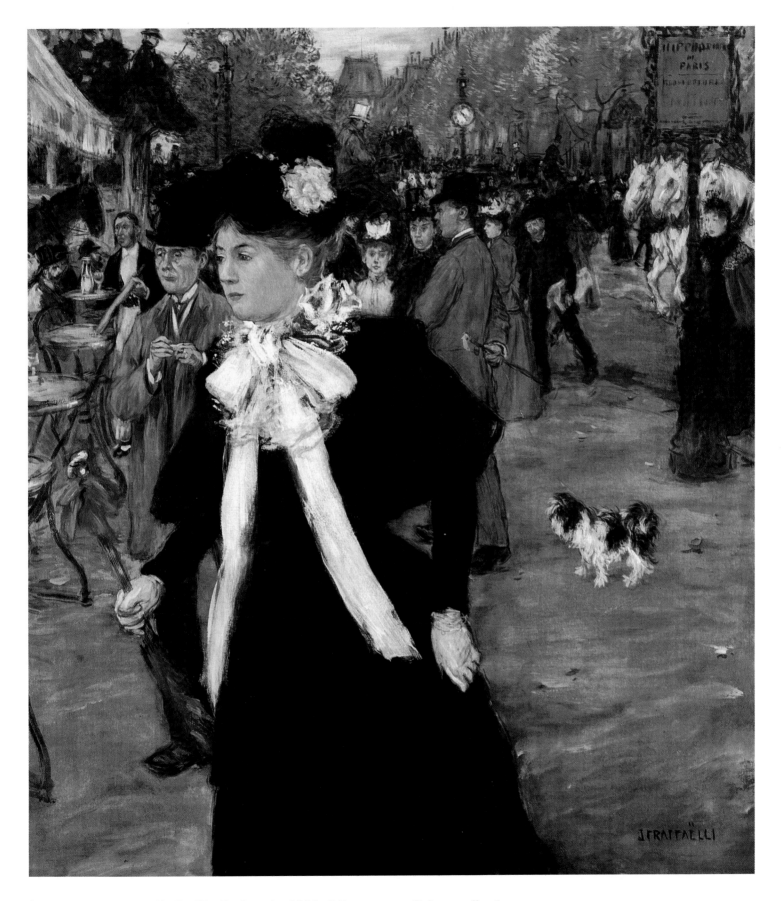

97. Jean-François Raffaëlli. *The Boulevard. c.*1890. Oil on canvas. Private collection

place, and his painting is in stark contrast to the costume pieces and landscapes he had produced before. It is the first of his *'peintures de caractère'*. In an essay of 1884, he defined 'character': 'Character, in effect, is that which constitutes the moral physiognomy in its constant and complete expression. Character is the physiological and psychological constitution of man. . . . Character is man's distinctive trait.' Raffaëlli considered that an emphasis on 'character' differentiated his art from that of the 'realists' (whom he did not identify), who copied nature without concern for depicting the most striking aspects of individuals. Although his views, based on those of Hippolyte Taine, were close to those of Zola and other 'naturalist' writers, Raffaëlli also rejected the term 'naturalism', considering that its emphasis on the 'scientific' made it inappropriate for the visual arts.

The Family of Jean-le-Boiteaux was shown at the 1877 Salon and was praised by the critic Edmond Duranty, but Raffaëlli's submission to the next Salon, *Place de l'Opera*, was rejected, and he was forced to reconsider his exhibition policy. Probably through Duranty, he had met Degas and become one of the habitués of the Café de la Nouvelle-Athènes, and Degas urged him to join the ranks of the independents, but in 1879 Raffaëlli had two works, both in his new manner, accepted at the Salon. They were *The Return of the Ragpickers* and *The Old Couple*. Raffaëlli was now entirely concerned with representations of the old and poor, and particularly with those who scratched a living at the margins of urban society, like ragpickers (Pl. 89).

At this time that he moved to Asnières, a suburb of Paris on the left bank of the Seine, to the northwest of the city, which was renowned as a great centre for boating, and was a favourite leisure spot for Parisians. There were few ragpickers to be seen in Asnières itself, essentially a bourgeois place, but across the river at Clichy the stark contrast between the two banks of the river became manifest: Clichy was 'covered with coal dust thrown up by the stevedores unloading barges, lined by workshops plastered in soot, rough wineshops, shanties strewn with rags' in Louis Barron's description in *Les Environs de Paris* in 1886. Directly adjacent to Clichy, at Levallois, were the shanty dwellings of the ragpickers and beggars on whom Raffaëlli now focused his attention.

The ragpickers as 'types' had long attracted graphic artists and writers, and were a favoured subject in the 'physiologies', collections of images of characteristic types, which were extremely popular from the 1840s on: *Les Français peints par eux-mêmes* was the most famous of such series. Particularly in his small paintings, such as *The Ragpicker* (Pl. 91), Raffaëlli's work conforms closely to the precedent of these 'physiologies'. In his immediate circle, both Duranty and Degas were fascinated by physiology and physiognomy. Duranty wrote in *The New Painting* in 1876: 'What we need are the special characteristics of the modern individual—in his clothing, in social situations, at home, or on the street.'

The Ragpicker's small size is significant. Raffaëlli minimizes any threat which such marginal figures could have posed to the urban bourgeoisie by reducing the image to a miniature, a cabinet picture, which is intriguing rather than menacing in any way. The details of face and clothing are finely painted, in contrast to the summary urban landscape in the distance. In 1881 the critic Gustave Geffroy warned Raffaëlli not to succumb in such 'miniatures' to the facile charms of Jean-Louis-Ernest Meissonier, known for his intimate cabinet pictures: the size of the work serves to distance it and to sentimentalize the subject. Raffaëlli made his own position clear many years later:

When one paints the people, one must never have pity on their state, under penalty, if one appeals to pity, of degrading them and degrading oneself, nor should one flatter them or paint them as sublime, as have done certain unphilosophic painters. One should paint them in their place, with kindness and sympathy, while

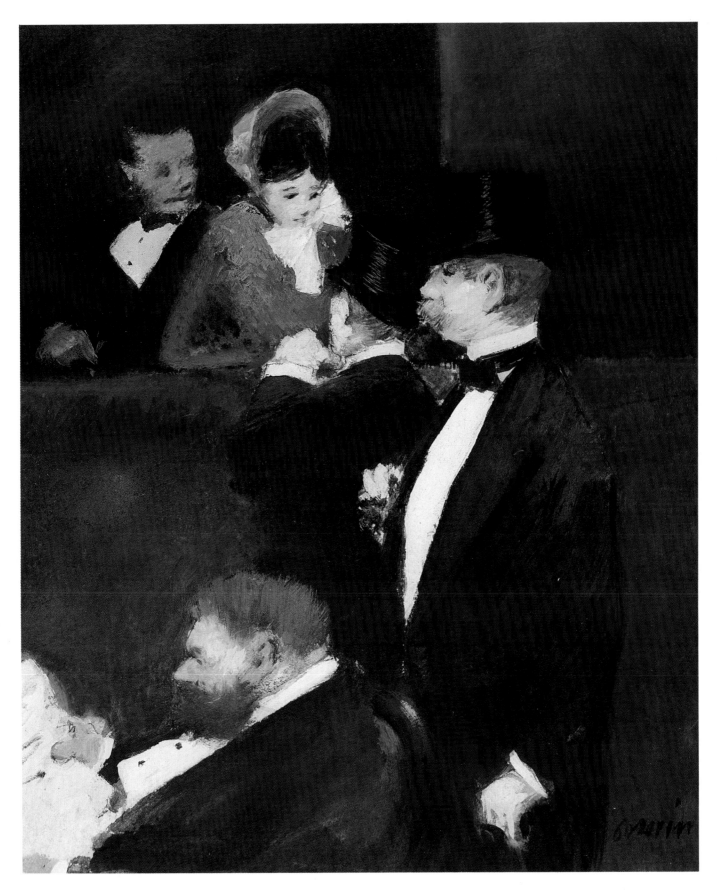

98. Jean-Louis Forain. *A Box at the Opéra. c.*1880. Gouache and oil on board, 31.7 × 26.8 cm. Cambridge, Mass., Fogg Art Museum

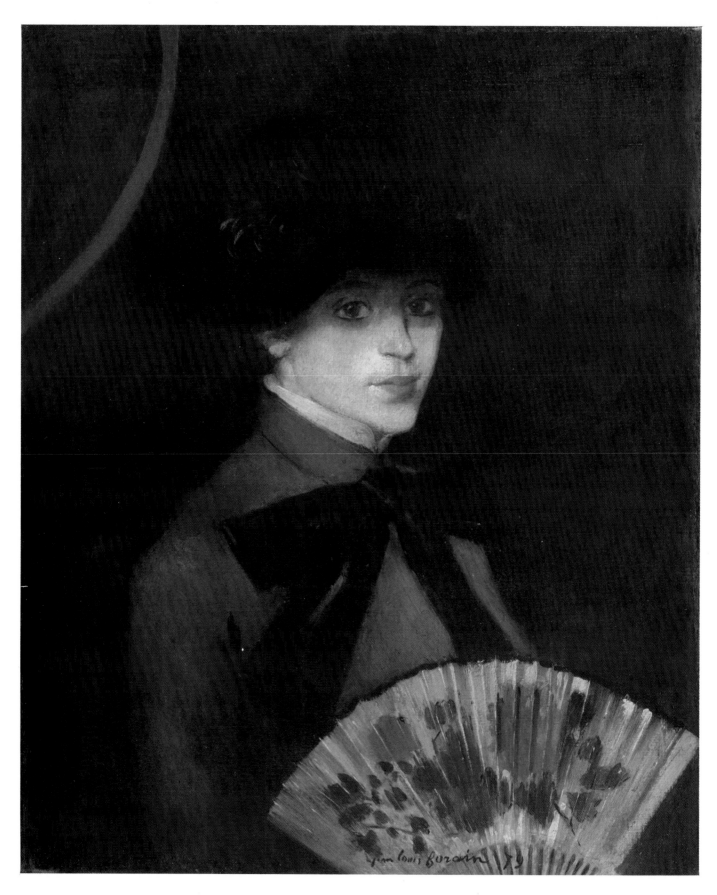

99. Jean-Louis Forain. *Woman with a Fan*. 1879. Oil on canvas, 50 × 43 cm. Boston, Boston Public Library, Wiggin Collection

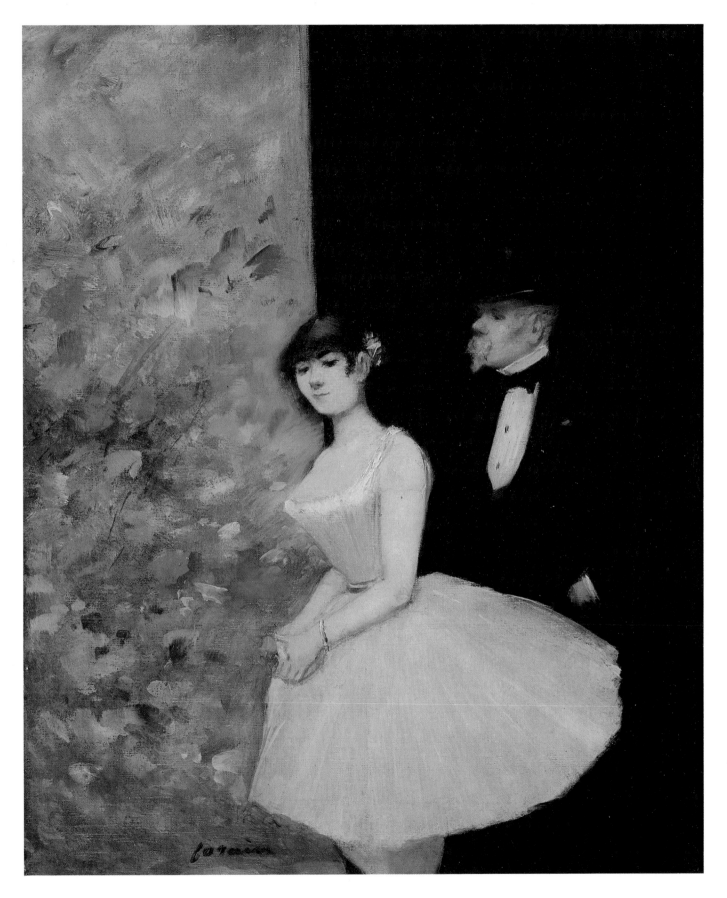

100. Jean-Louis Forain. *Behind the Scenes.* c.1880. Oil on canvas, 46.4 × 38.4 cm. Washington, D.C., National Gallery of Art

keeping one's distance, and with a profound aristocratic sense. It is the best way of showing them, whatever one may think of it, our brotherly feeling, and of raising them to our level, without risk for them or for us.

Raffaëlli did not only work on a miniature scale, and *The Absinthe Drinkers* (Pl. 93), shown at the sixth independent exhibition, is a large work. The café was a source of great interest to Raffaëlli (Pl. 92), as it was to Degas, and in a lecture in 1885 he suggested that artists turn their attention to cafés, 'from the sumptuous café to the den in the suburbs; from the café of neighbourhood tradesmen to the tavern where politicians hold forth!—What discoveries are there to be made!' In *The Absinthe Drinkers* Raffaëlli emphasizes the moral and psychological state of the drinkers. The literary quality of his painting appealed to critics like Huysmans, who seized the opportunity to embroider a moral tale in his review of the 1881 exhibition, concluding that each detail 'speaks volumes about their daily habits, about the ever renewed miseries of an inflexible life.'

Mayor and Municipal Councillor (Pls. 94, 95), shown at the fifth exhibition, focuses on the physiognomies of the two men, and was praised by several critics for its draughtsmanship, that quality found lacking in the work that was described as 'Impressionist'. Jules Claretie's comment that Raffaëlli was 'a sort of Meissonier of poverty, the poet of the Parisian suburbs, a singular temperament, half Flemish and half Parisian' is revealing. Recent discussion of Raffaëlli as a painter who exemplifies a bleak vision of misery obscures both the aspect of 'poetry' and Raffaëlli's recognition that there was a market for such scenes, as there was for peasant images. His contemporaries often saw his work as the equivalent of peasant or orientalist painting: in them is depicted a world remote from that of their audience, intriguing because of its difference, but not a threat to their security. His images of the urban wasteland were equated with Millet's peasant paintings, which were at that time fetching extremely high prices. The conservative critic Albert Wolff claimed that 'like Millet he is the poet of the humble', while Huysmans described him as 'a sort of Parisian Millet'. Peasant paintings in general were much in demand, and Raffaëlli's work may be seen as a shift in what was meant by that category, to include the urban poor. Jules Bastien-Lepage was exploring much the same kind of subject matter in works like *Nothing Doing* (Pl. 96).

When Raffaëlli showed in the group exhibitions, he had on view the largest number of works by a single exhibitor, thirty-five paintings in 1880 and thirty-six in 1881. Albert Wolff, unfailingly hostile to the independent exhibitions, recognized as clearly as some of the exhibitors or former exhibitors themselves that Raffaëlli was not an Impressionist: 'His tightly wrought art has nothing to do with the formless rapid sketches of the ladies and gentlemen of Impressionism. Why the hell did Raffaëlli join this enterprise?'

Part of the answer to Wolff's question must be that Raffaëlli's contemporary paintings had had mixed success at the Salon, and he must have welcomed the opportunity provided by the juryless shows to display such a substantial body of work. Some of the paintings were loaned by collectors, among them Edmond Duranty, Huysmans, Jules Claretie and Wolff himself, all of whom, perhaps unsurprisingly, wrote in his praise. One work in 1881 was loaned by the dealer Georges Petit, then vying with Durand-Ruel as the leading contemporary art dealer in Paris. The exhibitions gave Raffaëlli considerable publicity, and he decided to return to the Salon. However, both in 1882 and in 1883, his submissions were refused, and in 1884 he rented an empty shop on the Avenue de l'Opéra in order to stage a huge solo exhibition. He showed a total of 155 works and found a substantial number of buyers, sales totalling 30,000 francs by the end of the exhibition. By the 1890s, Raffaëlli was painting views of the Parisian boulevards (Pl. 97) which were unfailingly picturesque and touristic, and in later years, he extended the range of these picturesque views to the French countryside and the harbours.

101. Jean-Louis Forain. *The Tight-rope Walker. c.*1880. Oil on canvas, 46.2 × 38.1 cm. Chicago, Art Institute of Chicago

Jean-Louis Forain was another of Degas's recruits to the independent exhibitions. Forain was born in Reims in 1852, the son of a house painter. His family moved to Paris in about 1860, and in 1867–8, Forain was briefly enrolled at the École des Beaux-Arts in the studio of Gérôme. A year later he met the sculptor Jean-Baptiste Carpeaux, whose sculpture *The Dance* (Paris, Musée d'Orsay) had just been unveiled at the Paris Opéra. Forain became Carpeaux's pupil for a short while, but was expelled from his studio in 1870. Thereafter he became a pupil of the graphic artist André Gill, with whom he remained until he was called up for military service in 1873. By this time Forain was a close friend of the poets Paul Verlaine and Arthur Rimbaud, and was part of the literary and artistic circle that gathered at the hostess Nina de Callias's salons, and which included Manet. Forain illustrated Rimbaud's poem *Les Mains de Jeanne Marie* in 1871, the first of many illustrations he was to do for his Symbolist friends.

When he returned to Paris from the army, he submitted to the Salon of 1874 but was rejected. He soon became a regular member of the group at the Café de la Nouvelle-Athènes (Pl. 26) and a friend of Degas, who commented: 'The little Forain is still hanging to my coat-tails, but he'll go far if he lets go of me.' When Forain participated in the fourth group exhibition in 1879, he showed twenty-six items, including four fans, drawings, watercolours and paintings. The element of caricature in his work was noted by several critics, but he received considerable praise. Arséne Houssaye, writing under the pseudonym F.-C. de Syène, commented in *L'Artiste*: 'In a series of ruthless and candidly captured watercolours, Forain unrolls before us the life of the dandies who parade their dismal stupefaction from the cafés of the boulevards to the lobbies of the little theatres.' *A Box at the Opéra* (Pl. 98) and *Woman with a Fan* (Pl. 99) are characteristic of these images of the nightside of *la vie moderne*. *A Box at the Opéra* is in gouache and oil on board, and it is notable that Forain, like Degas, experimented widely with a variety of media and mixed media during his period of association with the independent group. *Café Scene* uses a mirror behind the female figure, set at a diagonal to the picture plane, to establish a complex space and to evoke the atmosphere of the cafés, which used mirrors extensively not only to increase the sense of space, but to heighten the sense of their being fantastic, glittering places. In this it could be compared to Caillebotte's *In a Café* (Pl. 70) and to Manet's *A Bar at the Folies-Bergère* (London, Courtauld Institute Galleries).

Many of the themes Forain depicted had been familiar in graphic work, popular prints and book and journal illustrations since the 1840s. *Behind the Scenes* (Pl. 100) was a subject to which Forain returned frequently: the gentleman admirer backstage at the ballet and the young dancer, or *rat*. The encounter presented here was so enshrined in the organization of the Opéra that an elaborate hall was provided for the backstage admirers to watch the dancers limbering up. Forain's work at this time retains much of the caricatural element and the acidic comment on contemporary morality of his master Gill, illustrator of numerous books on contemporary society. He seldom produced oil paintings, and Huysmans, writing in 1881, believed that 'the public will never accept M. Forain as a painter simply because he uses watercolour, gouache, and pastel, and devotes himself but rarely to oils.'

By the early 1880s Forain was becoming dissatisfied with the exhibition and sales possibilities afforded by the independent exhibitions, and he began to work in oils more frequently. One example is *The Tight-rope Walker* (Pl. 101), depicting the tight-rope walker in her red and blue tutu above the heads of a night-time crowd at an open-air theatre or café-concert. The gaslight makes strange masks of their faces, and the figure of the acrobat is dramatically lit against the dark sky. Degas's importance to Forain is still evident here, and Henri de Toulouse-Lautrec, who was Forain's neighbour in Montmartre from 1884, admired such examples of his work, writing to the Belgian neo-Impressionist Théo van Rysselberghe in 1888: 'I have done works close to those of Forain . . . his paintings are a real feast.' Forain also began to incorporate some of the compositional devices which were familiar in Salon

102. Jean-Louis Forain. *Place de la Concorde*. 1884. Oil on canvas, 71 × 51 cm. Private collection

naturalism, notably the striving for unusual angles of vision in his work. *The Fisherman* (Pl. 103) is an instance of this: the oblique angle of the pier makes a dramatic view of a potentially commonplace one. Forain's technique approached closer to that of Salon painting as he attempted to woo potential buyers. In this he was successful: whereas only two of his works, both watercolours, at the 1881 exhibition were lent by private owners, eight of his thirteen submissions to the eighth exhibition in 1886 were loans, six from private collectors, two from Durand-Ruel.

One of the oils Forain exhibited in 1886 was *Place de la Concorde* (Pl. 102). The buildings in the background are the Ministère de la Marine and the Madeleine, and Forain painted the scene at dawn from a hired cab. The meeting of the all-night reveller, a lean elegant figure in his top hat, and the stocky, overall-clad worker was initially regarded as the success of the exhibition by the critics. The painting was described as very modern and Parisian. Gustave Geffroy was less complimentary: he regarded it as anecdotal. The more avant-garde critics were united in regarding Forain's work in 1886 as proof that he had abandoned the biting satire of his earlier work in order to join the ranks of slick painters of modern scenes such as Béraud and de Nittis. Octave Maus, the Belgian critic, noted the unevenness of his work, 'slipping often on the slope of anecdotal illustration', more successful 'when he studies our elegant and vicious customs from life, in giving his works a particular flavour. He is the poet of corruption in evening clothes, of dandyism in the boudoirs, of high life masking empty hearts.' The fact that Forain had returned to the Salon in the previous year and that Durand-Ruel owned two of the works did not go unremarked, and Jules Christophe commented that 'savagery is adapting itself to highly accepted "conformity".'

By 1886 the conditions which had made the independent group shows seem a necessity in the early 1870s had changed: there were more dealers and other avenues available for the showing of contemporary painting, most notably the annual jury-free exhibitions of the Société des Indépendants. Only a few of the artists exhibiting could still easily be labelled as 'Impressionists'. For the majority, as Martha Ward has noted: 'the show in the spring of 1886 marked the point when the movement of Impressionism entered the ranks of history: a norm that most critics accepted, that dealers sought, and some artists aimed to surpass.'

The artists included in this book were very diverse in what they contributed to the group exhibitions. Their approaches to painting were equally diverse, ranging from Barbizon landscape painting through a variation on Pissarro's landscape painting of the 1870s to a form of naturalism which might have been equally at home in the Salon. The contribution of these artists is integral to any historical understanding of the eight group exhibitions—and thus to the work of the key Impressionists—in their original contexts.

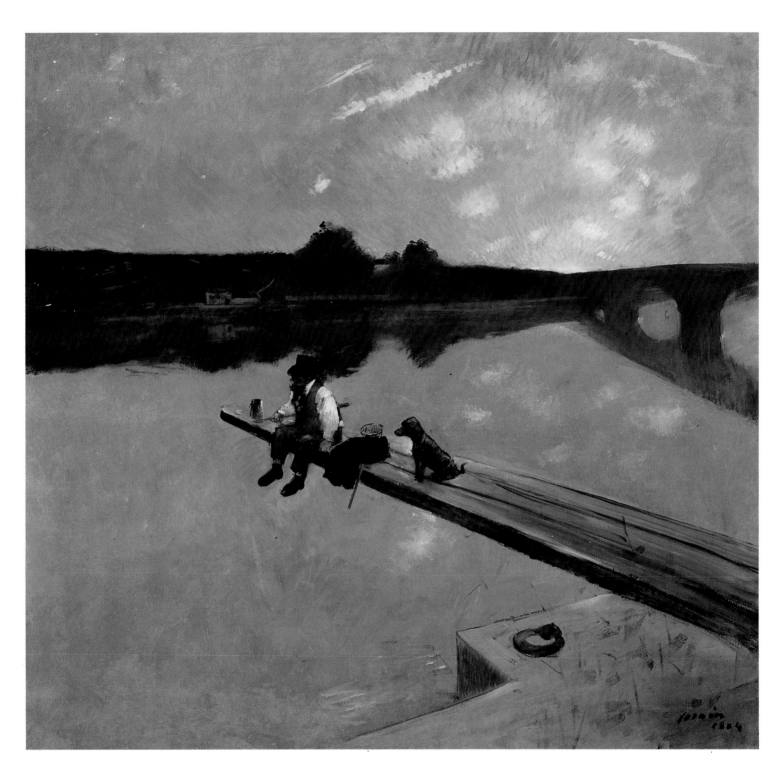

103. Jean-Louis Forain. *The Fisherman*. 1884. Oil on canvas, 96.5 × 99 cm. Southampton, Southampton City Art Gallery Collection, Chipperfield Bequest

Select Bibliography

TAMAR GARB, *Women Impressionists*, Oxford, 1986.

JOHN HOUSE, 'Impressionism and its Contexts', *Impressionist & Post-Impressionist Masterpieces: The Courtauld Collection*, New Haven and London, 1987.

JOEL ISAACSON, *The Crisis of Impressionism 1878–1882*, Michigan, 1980.

CHARLES S. MOFFETT *et al.*, *The New Painting: Impressionism 1874–1886*, Oxford, 1986.

SOPHIE MONNERET, *L'Impressionnisme et son époque*, 4 vols., Paris, 1978–81.

JOHN REWALD, *The History of Impressionism*, New York, [1946], 1973.

I am indebted to a wide range of sources. In addition to the works cited in the bibliography, I wish in particular to acknowledge the following publications: Janine Bailly-Herzberg, *Correspondance de Camille Pissarro*, vol. 1 *1865–1885;* vol. 2 *1886–1890*, Paris, 1980, 1986; Marie Berhaut, *Caillebotte, sa vie et son oeuvre: Catalogue raisonné des peintures et pastels*, Paris, 1978; Richard Brettell, Scott Schaefer *et al.*, *A Day in the Country*, Los Angeles County Museum of Art, 1984; Lillian Browse, *Forain the Painter (1852–1931)*, London, 1978; D. Chambers, *Lucien Pissarro: Notes on a Selection of Wood-Blocks Held at the Ashmolean Museum*, Oxford, 1980; Madeleine Fidell Beaufort and Jeanne K. Welcher, 'Some Views of Art Buying in New York in the 1870s and 1880s', *Oxford Art Journal* vol. 5, no. 1, 1982, pp. 48–55; Dillian Gordon, *Edgar Degas: Hélène Rouart in her Father's Study*, London, 1984; Jean-Philippe Lachenaud *et al.*, *Pissarro et Pontoise*, Pontoise, 1980; Christopher Lloyd and Richard Thomson, *Impressionist Drawings from British Public and Private Collections*, Oxford, 1986; Roy McMullen, *Degas: His Life, Times, and Work*, London, 1985; Enrico Piceni, *De Nittis: l'uomo et l'opera*, Busto Arsizio, 1979; Enrico Piceni, *Zandomeneghi, l'uomo et l'opera*, Milan, 1979; Richard Shiff, *Cézanne and the End of Impressionism*, Chicago, 1984; Richard Thomson, 'Jean-Louis Forain's *Place de la Concorde:* A Rediscovered Painting and Its Imagery', *The Burlington Magazine* 125 (March 1983), pp. 157–8; J. Kirk. T. Varnadoe and Thomas P. Lee, *Gustave Caillebotte: A Retrospective Exhibition*, Houston, 1976; Gabriel P. Weisberg *et al.*, *The Realist Tradition: French Painting and Drawing 1830–1900*, Cleveland, 1980.

Photographic Acknowledgements
65, back jacket: Bayeux with special permission of Collection M. Baron Gerard; 46: by courtesy of Birmingham Museums and Art Gallery; 15: Frederick Keppel Memorial Fund, gift of David Keppel, courtesy Museum of Fine Arts, Boston; 26, 99: courtesy of Boston Public Library, Print Department; 79, 86: Bramante Editrice di Busto Arsizio; 98: bequest of Annie Swan Coburn, 1934; 64: Charles H. and Mary F. S. Worcester Fund, © 1987 The Art Institute of Chicago, all rights reserved; 76: Helen Birch Bartlett Memorial Collection, © 1987 The Art Institute of Chicago, all rights reserved; 101, jacket: gift of Emily Crane Chadbourne, © 1987 The Art Institute of Chicago, all rights reserved; 61, 84, 96: National Galleries of Scotland, Edinburgh; 31, 39, 41, 81; 83: Scala, Florence; 54: John A. and Audrey Jones Beck Collection; 69: Bridgeman Art Library; 22, 24, 43: reproduced by courtesy of the Trustees of the British Museum; 53: © Christie's; 102: Christie's; 5, 7, 32, 60, 78: reproduced by courtesy of the Trustees, The National Gallery, London; 59: Atelier 53, Paris; 10, 11, 66, 73, 75: Giraudon, Paris; 62: J. Hyde, Paris; 68: Studio Lourmel, Photo Routhier, Paris; 17, 18, 19, 23, 30, 45, 52, 55, 63, 82: Cliché des Musées Nationaux, Paris; 58: acquired through the generosity of the Sarah Mellon Scaife family, 1969; 18: Photo, M. Jean Pierre Levallois; 74: Collection of Mr and Mrs Paul Mellon; 100: Rosenwald Collection 1943; 35: Eliza S. Paine Fund.

Index

Figures in **bold** are plate numbers.

Some road stars find it difficult to adapt themselves to the speed and atmosphere of an indoor track.
Not so Tom Simpson, who was already an accomplished performer on the path before taking up road work. Here is Tom in the Brussels six-day race handslinging his partner, Freddy Eugen, of Denmark.

When Tom Simpson came to London in February for Corona press lunch, his immediate goal was San Remo. Here he had moment of victory in the Italian race with Poulidor beaten.

THE SPORT OF KINGS OF THE ROAD & TRACK

Based at St. Gervais for cyclists' winter sports championships, they were able to the nearby Sallanches circuit. But, as these pictures show, the winter sports were favourite

looy had based his whole season on the Tour de France, which enter Belgium on the third day. He, in his Belgian championship, promised to be wearing the yellow jersey in Brussels. But on day he crashed two miles from the finish, and (left) we see ing in dejectedly 4min behind the winner, in company with Van too, another victim of the accident (No. 16 is Barry Hoban), How Van Looy rode most of the stage next day before retiring.

like the above are not uncommon in the Tour; it is in memory of ral of the Tour (in shorts) and his co-Director, M. Felix Levitan, with the riders for a minute's silence. Usually it is in memory of Tour personality who has recently died. On this occasion, at Brive, occasion was particularly solemn. The previous day at Porte-de-Couze, ht spectators of the Gendarmerie, crashed into a canal bridge. copters of the Gendarmerie, crashed into a canal bridge.

elow: Drama on the Envalira Pass. Armand Desmet (Belgium) has had s crash; he is carried to the Aspro helicopter ambulance while a d rider crouches low as he passes under the blades.

SPORTING CYCLIST

SIMPSON'S BORDEAUX-PARIS

PEUGEOT